TINCRAFT for CHRISTMAS

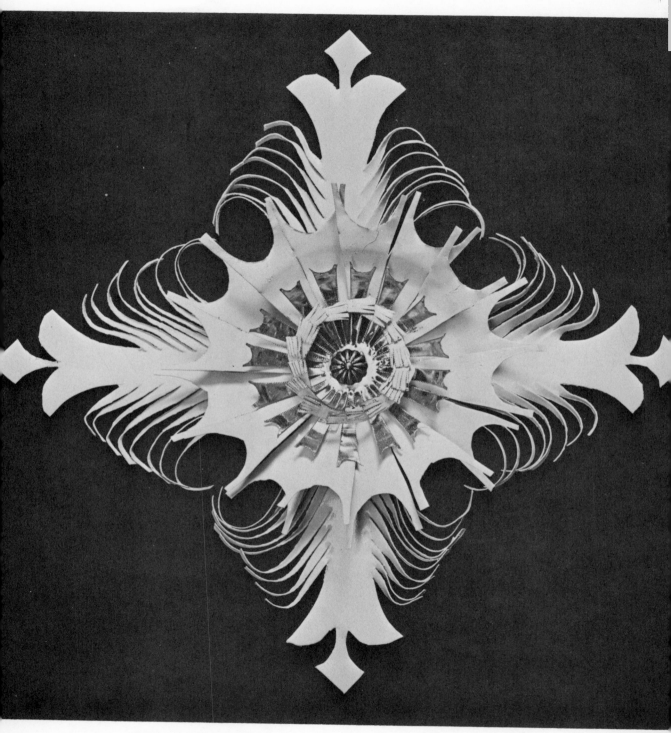

Swedish Star Rosette: Composite of Fringed Whorl, Staghorn Circle, and Swedish Star.

TINCRAFT
for CHRISTMAS
by Lucy Sargent

Designs and Drawings by the Author
Photographs by George C. Bradbury

William Morrow & Company, Inc.
New York

Printed in the United States of America.

Library of Congress Catalog Card Number 68-56413
●●

To Helen Van Pelt Wilson, with love and gratitude
for giving me the idea, the inspiration,
and the opportunity of writing
this book

CONTENTS

Contents

LIST OF ILLUSTRATIONS

IN COLOR

IN BLACK AND WHITE

FIGURES

Line Drawings

It Came Upon a Midday Clear . . .

Driving along under broad Canadian skies one summer, I said to my two youngest, "Think Christmas, and tell me what pops into your head."

And my brown-eyed, blonde-haired daughter, aged twelve, answered directly, "Singing carols and giving presents and friends . . ."

And my gray-eyed, Beatle-haired choir boy, aged fourteen, said dreamily, "Midnight service on Christmas Eve and snow swirling and bells . . ."

"What about a Christmas tree?" I asked. "I thought you'd put that at the top of the list."

"Oh, well," they chorused. "You can't have Christmas without a tree!"

"Couldn't we," I pleaded, "have just a small one for a change? You know, a little live one in a bucket, and camouflage it with cotton snow and make a cardboard village and . . ."

"Oh, no, Mummy!" they said, horrified. "It's got to be a big one—right up to the rafters."

"You mean," I said weakly, "ten feet tall and six feet through—as usual?"

"Of course," they cheered. "And we'll get it early this year and pick a really fat one."

"Well, then," I said firmly, "you'll have to help me make more ornaments. You remember how thin it looked from the back last year because so many of the paper things had worn out. It should be bouncy all over."

"Oh, sure, Mum. We'll make ornaments. No problem. When do we start?"

We started that very week making what we like to think are treasures, out of tin. Just ordinary—extraordinary—tin cans!

This is how we did it.

Westport, Connecticut Lucy Sargent
February, 1968

PART ONE

TOOLS, MATERIALS, AND TECHNIQUES

TOOLS AND MATERIALS

To put very first things first—that is, tin cans—let me reassure you that they are here to stay. A letter from a knowledgeable metallurgical engineer at the Tin Research Institute, Inc., states that the "use of metal cans will continue to rise in spite of some very minor encroachments by substitute materials,"—meaning, I suppose, those wretched cardboard cartons for orange juice, and those bags of freeze-dry foods for Boy Scouts and other intrepid campers of whom I seem to know an increasing number. The engineer tells me that between now and 1971, the total United States can units should rise from 55 billion to 67 billion. Isn't that encouraging? So let's not worry. Let's just abandon ourselves to the pleasures of playing with these erstwhile cast-off, now-found objects—tin cans.

They are beautiful. Just as beautiful as any precious metal, and much easier to work with. They are simply less durable. And that's all right. You and I are used to obsolescence—and we are also used to caring for things we cherish.

Tin cans come in an extraordinary number of shapes and sizes, ribbings, and linings, all directly related to stress and chemistry, I understand, but remarkably unstandardized for this day and age. The gold linings shade from palest champagne to bright to brassy to green to pearly to soft to rich to coppery—a wondrously poetical gradation that you and I are literally free to enjoy. The weight and temper of the metal varies from light to crisp to smooth to firm to hard. All these differentiations are discernible and delightful and it will become your pleasure to make use of them judiciously.

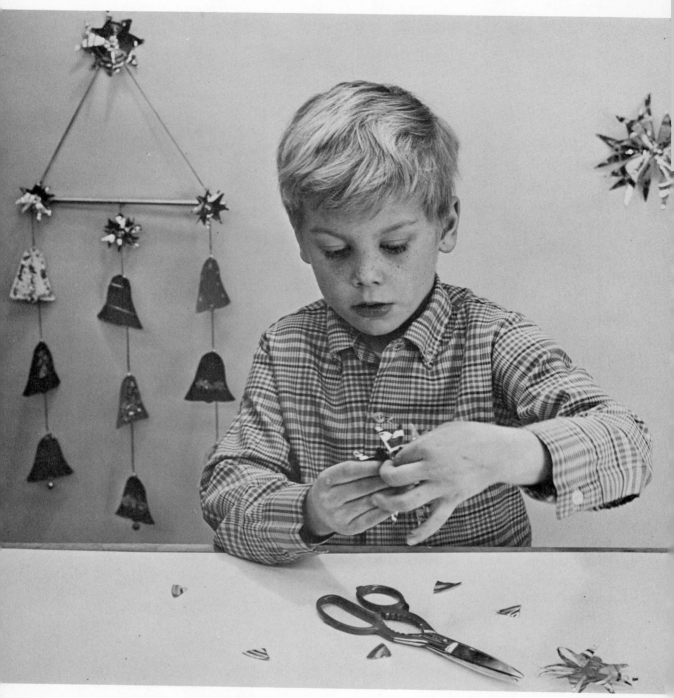

Seven-year-old Christopher Knox at work:
As you can see, stars and bells pose no problems for him!

Before you begin to make anything, you will want to know what you need in the way of equipment and materials.

Whenever anyone asks me about this, I am always tempted to say, "Just cans—and kitchen shears," because that is, essentially, all you *have* to have. But then I amend that statement and say, "Of course, if you become really interested, you will want a good pair of snips. They cost only a few dollars, and they cut through tin like butter and make the whole experience a pleasure."

And then, pursuing the subject farther, I realize that I have not one, but three, pairs of snips: one plain-edged, one finely serrated (with tiny teeth), and one coarsely serrated. And I couldn't get along without one of them. They do different things, and I need them all.

So, I will make you a list of the tools and materials I have found most useful. But don't be dismayed by the length of it. You will need only a few for any one project, and even then you can improvise for the moment with things you have around the house—such as a nail in place of an awl, and so on. But, if you get "hooked," as my respectable friends and I laughingly call it, you will find yourself voluntarily adding to the list and improving the quality and scope of materials. (A list of Sources of Supplies is given at the end of this book.)

PLAIN-EDGED SNIPS make an absolutely smooth cut and can easily be kept sharp by a local grinder. For that reason I use them for heavy-duty work, such as removing seams from cans, cutting strips, fringing rims, and of course, for cutting any design on which I do not want an ornamented edge.

FINELY SERRATED SNIPS are the ones to buy if you are only going to have one pair. The little teeth along the blades produce a beaded edge on the tin which catches the light pleasantly and provides a restrained, yet ornamental finish to a piece. Purchase the type that claims to cut *straight and in circles*. Wiss makes a beautiful pair. Try to find one with plastic grips on it, or buy grips to put on it, because sometimes you have to slug your way through the metal and need the knuckles on the grips to push against. Klenk makes a far more comfortable model (notice the difference in handles) and pride themselves on lifetime quality.

COARSELY SERRATED SNIPS have larger teeth and produce a highly ornamental, scintillating edge to any cut. Both the Christmas Comet and Sunburst Sconce depend upon these snips for their brilliance. However, since the serrations are so coarse, they have a tendency to turn, rather than cut, any metal that is light-weight or of small size. So, while they have definite distinction, they are not all-purpose. On the other hand, they produce the most impressive ornaments in my collection. Both these and the finely serrated snips have to go back to the factory for sharpening.

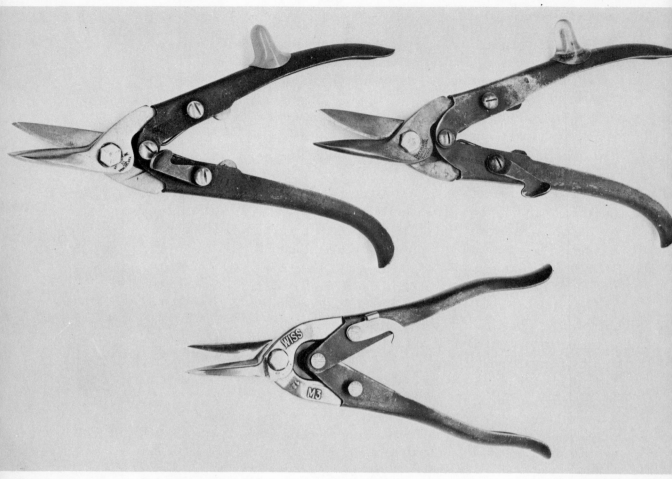

My Trusty Aviation Snips: *(Above)* Klenk coarsely serrated and plain-edged snips; *(Below)* Wiss finely serrated snips.

BALL-PEIN HAMMER: You will be in constant need of such a hammer, and if you want to make an apple or heart or any curved surface, you need one of this kind with a perfectly rounded head (absolutely no point on it) that weighs only eight ounces.

BOARD: Any hard-milled cutting board from the hardware store will do unless you have an odd piece of hardwood in the cellar. You will use it not only as a surface on which to hammer pieces flat, but also for making awl holes, so it must be hard but need not be good.

LONG-NOSED (CHAIN) PLIERS WITH WIRE CUTTER: *round* on the outside and *flat* on the inside, the longer and narrower the nose the better.

ROUND-NOSED PLIERS: perfectly *round* both *inside and outside,* the longer and narrower the nose, the better. Both pairs are *essential*.

AWL, or sturdy SCRIBER: for marking tin and making holes.

CHOPPING BOWL OR DAPPING BLOCK: for hammering *curved* surfaces. You must have a dapping block if you want to raise *only a portion* of a surface; otherwise, a kitchen chopping bowl will serve you well.

GREASE PENCIL: preferably red and preferably one that screws out rather than peels off.

COMPASS: cheapest variety perfectly adequate.

ARCHITECT'S LINEN: transparent, finely woven glazed cloth, far more durable and better for patterns than tracing paper.

RUBBER CEMENT: perfect for applying patterns because it rubs off clean with the fingers.

CLEAR CEMENT: Epoxies are good, but a nuisance. I find Weldit Cement very satisfactory, especially when I score the metal first.

FLORIST CLAY: This is, in some instances, easier to use than cement and just as satisfactory. Both Vogue Stikum and Posey Clay are good.

WIRE: You will need a spool of green florist wire and also the finest hair wire available.

SPRAY PAINT: Ideal for quick job on anything you want to have entirely one color and essential in painting anything elaborately cut. I have found no line superior to Krylon, although I occasionally use other brands when I find a color that is especially good. In the Krylon line, I would particularly like to call your attention to No. 1320 Metal Primer; it is the most beautiful shade of olive-green I have found.

NYLON- AND FELT-TIP MARKERS (The oil-based "permanent" type) come in a wide range of live, transparent colors, and are quick drying and easy to use. They are not durable, however, nor can they be sprayed with anything that I have yet found to make them durable. The solvents in Krylon Crystal Clear, for example, eradicate the color completely. I have used them, nonetheless, for many of my trinkets, but I make a point of handling those ornaments as little as possible and wrap each one separately in tissue paper for storing.

TRANSPARENT GLASS PAINTS: A Dutch company named Talens puts out

a nice line of fairly quick-drying, lustrous oil paints which I have found gener-ally satisfactory. They are less transparent than the felt markers but richer in color, and they are durable. In fact, baking them in the oven makes them virtually indestructible. Any ornament that you expect to treasure or to handle frequently, like a bookmark, should be decorated with these glass paints.

MODEL PAINTS: They are quick drying but usually opaque, although the me-tallic ones can give the impression of transparency. Be sure to buy the glossy colors, not the flat ones. They are good for the fun ornaments on the tree—the Santa Clauses and such. The Testor Insignia Red is the best Christmas red I have found, and the Pactra line has some luscious colors. But, by and large, I prefer a transparent paint on tin, especially at Christmas. Perhaps I am influ-enced by the charming Mexican tin one sees everywhere. When I find out the secret of their vivid colors, I will let you know. And if you already happen to know, please tell me!

BRUSHES: For this generally fine work I use a No. 1 sable.

UPHOLSTERER'S TACKS: There is only one upholsterer's tack that I consider usable. It is Decora No. R 148 J. Rather than use any other, I prefer to fringe a small circle of tin and glue a rhinestone in the center.

Other tools:
(Left) kitchen chopping bowl and maple dapping block; *(Right)* bread board, long-nosed pliers, ball-pein hammer, awl, round-nosed pliers, grease pencil, and compass.

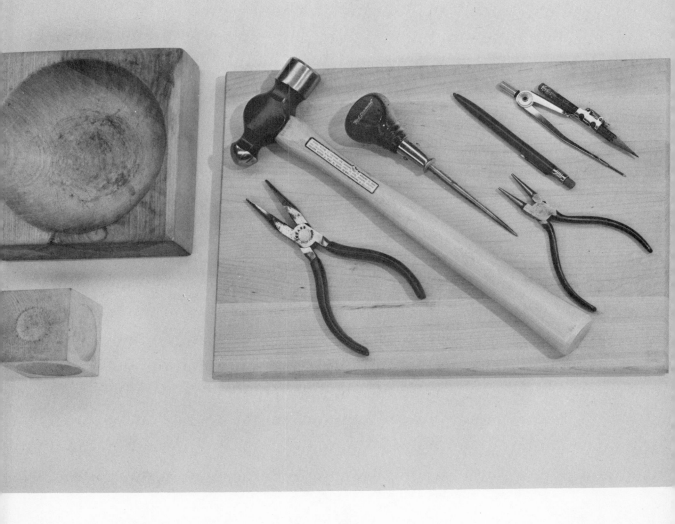

TECHNIQUES

There are certain basic techniques to tincraft that it might be useful for you to have noted down in one place. Here they are:

On Opening and Polishing Cans

You will need a good *wall* can opener. It need not be electric. Open the can as usual, remove the paper label, and wash it. If the can has a gold lining which you plan to use, do not scrub it with steel wool; use something softer to remove the food. Let it dry.

When ready to use the can, scrape the dried glue off the outside with a paring knife. Run the can under hot water, the hotter the better—it opens the pores and releases impurities. Burnish it while hot with *soapy* steel wool.

Most price marks on lids can be removed with mineral spirits and turpentine; all will succumb to nail polish remover, and, of course, to steel wool, but steel wool will mar some surfaces.

On Removing Rims

If you want to use the flattened side of a can, you must first remove the lids from both ends of the can; then the rims at each end; then the seam.

To remove the rims, put the can into the can opener *sidewise,* catching the rim under the wheel. Turn the handle as usual; off it comes. *Grasping the can by its waist,* to avoid being cut by the raw edge now on one end, place the other rim under the cutting wheel. Save the rims. They can be used in a variety of ways.

24

On Removing Seams, Flattening Sides, and Cutting Strips

Wear gloves. When you start cutting down one side of the seam, two irritating things will happen. The screw bolts on the snips will interfere with the cutting process and almost force you to make a jagged cut *if* you do not hold the can firmly. Furthermore, the length of the can may exceed the length of your snips and the sharp tin will catch on your gloves. Persevere! Keep the pressure of your snips *on the cut* to avoid making little slivery "hangnails" that may catch you unawares before you have a chance to trim them. Cut all the way *through in one direction*—coming back from the other side to meet the cut you've started is sure to make a jagged edge, and it doesn't ease the situation perceptibly. Cutting down the other side of the seam is no problem.

To flatten the sides, pull the can open with your thumbs, but not so quickly and vigorously that you put a crease in the ribs should you be planning to use them spherically (Kissing Ball). If, however, you plan to make stars or bookmarks for which you need strips, you can flatten the side easily and effectively by stepping on it.

In cutting strips of tin, wear gloves; hold the tin firmly; keep the pressure *on* the cut; slug through it. You'll think nothing of it after a time. You'll find that the ribs in the can make excellent cutting guides.

On Dividing Lids into Equal Sections

You can always find the exact center of a lid with a compass, but I just use my eye. You will, too, and you'll soon become good at it. Make a dot in the center of the lid with grease pencil. Then, placing the ruler ⅛ inch left of center to allow for the thickness of the grease pencil, draw a line across the lid.

Turn the lid so that the line you have just drawn lies horizontally before you. Find what your eye tells you is the center of that half circle. Mark the point with grease pencil and draw a second line perpendicular to the first.

Cut along those lines as far toward the center of the lid as the design requires. Abandoning the grease pencil, divide those sections in halves *by eye,* to get eighths. Divide *those* sections in halves to get sixteenths.

You can always find the center of a section and cut it truly if you turn it around so that you are facing it squarely.

On Dividing Sides of Cans into Equal Sections or Making Spokes

If you are a mathematical genius, you can always divide the side of a can into equal sections by measuring its circumference with a tape

measure and dividing the figure (usually uneven) by the number of sections you want.

But a far easier method is to cut a piece of plain paper to *fit the circumference exactly* (making it short enough to fit within the rims). Fold it in half three or four times, depending upon whether you want eight or sixteen sections. If you make nice sharp creases, you will be able to see them well enough to cut by, *even after gluing* the paper to the can with rubber cement. Otherwise, you will have to rule in the lines along the folds.

On the Reaction of Tin to Tools

You will find that your tools have different effects upon tin. When cut by any snips or scissors tin *curls down on the right* of the blades and *up on the left.*

The *narrower* the strip you cut, the *tighter it curls.* That is the secret of the elaborate stars you will find in this book. Those curls will not be all equally curly, and you may have to help them along a bit with your fingers or with your round-nosed pliers, but the inclination is there. Always *work with that inclination,* and you will get a graceful curve. If you work against it, the tin will crease.

By creasing I mean that an awkward angle is formed. Some awkward angles made in cutting out a pattern can be corrected by hammering the ornament on the board. But hammering would not be feasible for correcting a crease in a tendril on a complicated star for too many other tendrils would be in the way. There you must first *straighten* the tendril with the *long-nosed pliers* which are *flat* inside. Then recurve the tendril, either with your thumb and forefinger (if you can get them in there) or with the *round-nosed pliers* which are *round* inside.

Generally speaking, use long-nosed pliers to straighten or flatten a piece, and round-nosed pliers to curve it.

When *hammering* tin, there is a tendency for the metal to *curve up* around the point you are hammering. This can be very useful, because it works both ways—you can *curve* a piece by hammering it *on one side only,* and you can make it *perfectly flat,* by turning it over and hammering it on the other.

On Beating Tin

There is a natural temptation when working in a two-dimensional medium to want to give it the appearance of three, especially when a third dimension enhances the texture and sheen of the material, and the

Dividing the side of a can into equal sections.

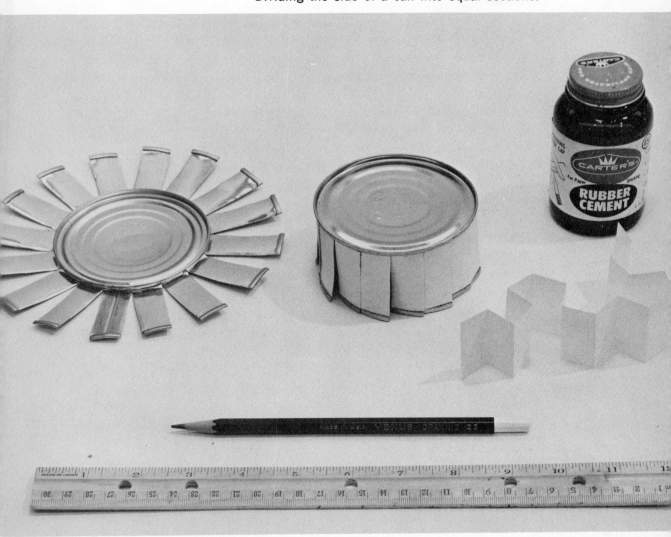

result not only looks lovely but well wrought as well. Beaten tin has this charm. You must have a ball-pein hammer and a wooden mold of some sort. I use both a proper dapping die and a kitchen chopping bowl, depending upon the size of the ornament and the area of surface I want to raise.

If you want to curve a whole piece, simply place the outermost edge across the bottom of the chopping bowl and hammer back and forth along it with short, fine strokes, gradually working toward the center of the piece. This must be done patiently and thoroughly or you will get creases in the circumference which you will only have to go back and hammer out. When finished, the ornament should be completely covered with little hammer marks and have a satiny, velvety sheen.

If, however, you want to raise only the center portion of an ornament, you will have to purchase a dapping die which is a small block of maple wood with cup holes of various sizes in it. You will probably find the smallest one the most useful in making the ornaments in this book. Center the ornament over the circle and, with tiny hammer marks, work round and round gradually enlarging the hammered area until the tin conforms to the hole. If you need an even larger area raised, move to the next largest cup hole in the die, etc. Flatten the remaining surface of the ornament by hammering it on the level border of the die.

On Fringing Tin

Fringing is merely making narrow parallel cuts along the edge of a piece of tin with serrated snips. Make each little strand of fringe *no less than* ¹⁄₁₆ of an inch wide and *not as much as* ⅛ of an inch wide, *regardless of* the *size of the piece* you are working on or the depth of the fringe you are cutting. Ordinarily, one alters the proportions of a design to correspond to the size of the ornament, but not with fringe. You vary only the depth, not the width.

You will discover as you leaf through this book that I love fringe. It has a pleasing dual personality, being both simple yet sophisticated, combining casualness with elegance. It lends itself to both large and small forms—from door wreaths to lapel pins—and it is easy to make.

On Ornamenting Rims

As they come from the can opener, rims look pretty raw. Do not trim off that raw edge. Make vertical cuts in it instead. Working around the rim counterclockwise, cut right up to the rim itself at ¼-inch intervals. Use the very tip of your snips and *snap them shut* against the rim edge.

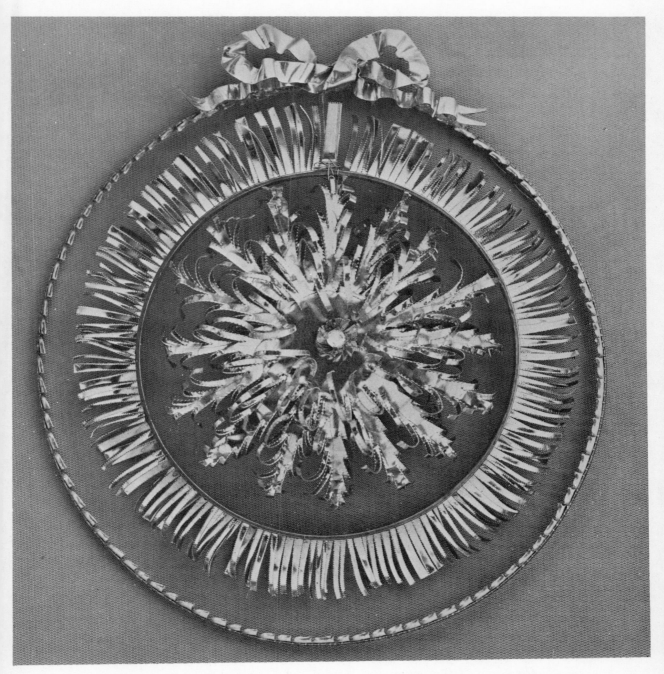

Frosty Star window ornament illustrating the technique of fringing and ornamenting rims.

This turns the metal *diagonally* and provides a uniform, finished ornamentation to the most ragged of rims. I designed the Snowflake Tree just to demonstrate the beauty intrinsic in cast-off rims.

On Making Scrolls (Color Plate 3, Sunflower Sconce)

Scrolls are curved strips of metal used (for the purposes of this book) either to support candles or to suspend chimes. To make them rigid enough, folds at least 3/16 of an inch wide must be made on either side of the strip. My method is far more casual than professional, but it seems to work.

Cut a strip 1½ inches wide from the side of any heavy can (V-8 juice is perfect because of its bright gold lining). Place it along the edge of your hammering board (or workbench or kitchen chopping block, etc.) so that it extends 3/16 of an inch beyond. Holding it firmly in place, tap it with the hammer at each end, bending the tin down enough to help you keep it in line. Then hammer all along the edge until it forms a neat right angle. Turn it over and hammer the folded edge flat. Do this along the other side. Cut one end in a curve to make it less stubby and more ornamental. Then wrap that end around a pipe or broomstick until it forms a scroll. Happily, my husband has a vise and lots of old pipe, which means that I can fasten the pipe firmly in the vise and hammer the strip around it, thus keeping the folds nice and sharp and making a perfect curve. You can improvise, however, by placing a broom handle across the kitchen sink.

On Making and Applying Patterns

It may be that because of advanced duplicating processes architectural linen will eventually become obsolete, but it is still available and is still the best medium for making patterns. Tracing paper is not only fragile, it absorbs the cement and is, therefore, harder to pull off the tin. Consequently, it tears, and you find yourself having to make another pattern. Also, the snips can easily cut tracing paper, whereas they only move to one side the stiff architectural linen.

Ordinarily, one has to buy a yard of architectural linen at a time. You will, therefore, have to cut it into usable pieces, such as 4 × 8 inches for some of the ornaments, and 4 × 4 for others.

When tracing the design onto a section of architect's linen, place the piece *dull-side up* on the pattern in the book and trace it off with pencil.

Usually, you will cut the pattern out before applying it to the tin; and then, once pasted on, will cut around the edge of it.

But if you want to transfer an *interior* pattern to tin (such as the facial features of the Mexican Sun), you obviously cannot cut out the pattern. Instead, you will center the pattern over the lid and, with ball-point pen and carbon paper, go carefully and firmly over the design, thus transferring it to the tin. You will find that the unevennesses in the tin may make this tracing process difficult, but if you go slowly, and have patience, you will get the design accurate enough to go by.

I do not like the blackness of the carbon paper because it can show through and spoil the color of the transparent paint, but so far I have found no substitute. I would suggest that you trace only the most essential parts of the designs I have given you and fill in as much as you can freehand, comparing your drawing to the one in the book.

On Cutting Out Patterns

Except for bending up or down, tin is unyielding, which makes cutting corners a problem. And yet the more perfectly an ornament is cut out and the more detailed it is, the more of a treasure it becomes—and that is, after all, our aim.

In general, when cutting out a pattern, hold the tin *without touching the pattern.* Your pressure will move it.

Cut around the pattern as fastidiously as possible, starting at the right edge and cutting around counterclockwise if you are right-handed, and vice versa if you are left-handed.

Bypass any *corners in the design that come toward you. Go into* the corners that run in the same direction as your snips. (Come back later, from the opposite direction, and get those bypassed corners.)

In any tight spot, always *work with the very tip* of your snips—the last ⅛ or even ¹⁄₁₆ of an inch of them. And *take only tiny ¹⁄₁₆- inch bites* forward.

In cutting around to the right, keep your hand (and as much of the snip as possible) *down under* the tin. In cutting around to the left, get above the tin. But *on any curve,* regardless of the direction, use only the tip of your snips and make only tiny cuts forward. When finished (or even as you go along) hammer the ornament flat and trim any imperfections.

On Handling Tin

One more word about the handling of tin. So many people are worried about the sharpness of it—the very same people who use carving knives absent-mindedly, grow ravishing (but thorny) roses, and dine

enthusiastically on broiled-live lobster and Alaskan King Crab. Believe me, the hazards of tincrafting cannot compare with the hazards of housekeeping or of gardening or even of cold winter weather.

You will quickly learn to pick up any piece of tin *lightly,* and, when necessary, hold it *firmly.* Wear gloves for the tough work if it puts your mind at rest, but mostly you won't want to. Work in good light, preferably daylight, standing with your back to it so that light comes across your shoulders onto the tin.

But the real secret of success lies in approaching the craft with curiosity and interest—and plenty of time! Don't hurry! Copy some of my things until you get over that lost, formless feeling and acquire a sense of the medium. Play with it. Fuss over it. Then you'll find, much to your amazement, that the tin itself is giving you ideas. And that your need for both practical and beautiful things about the house will suggest ways of using this found metal. Before very long, I assure you, you will never look at a Picasso or a Calder—or a tin can—with the same eyes again! So, have fun!

PART TWO

TRIFLES FOR THE TREE

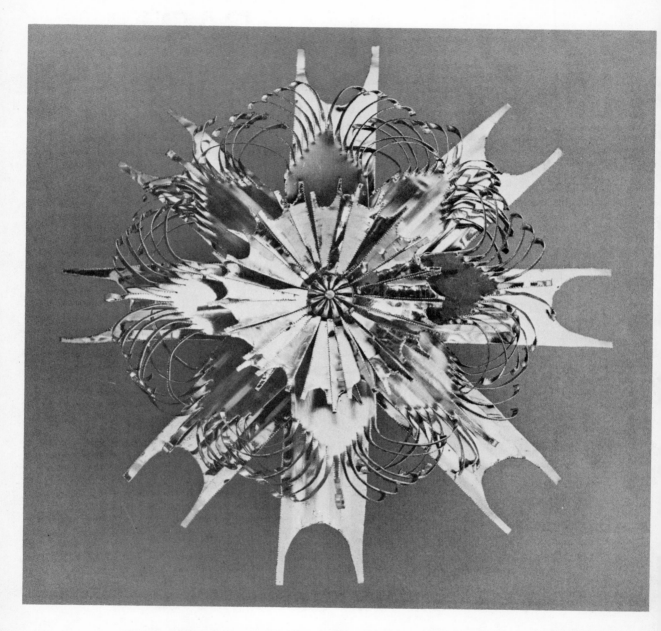

Little Treetop Star: composite of Staghorn Circle, Imperial Star, and Staghorn Scandinavian Star secured with ornamental tack.

START WITH A STAR

After considerable thought, I've come to the conclusion that a star is the most universal symbol of Christmas. At first it seemed to me it could just as well be Santa Claus . . . or a reindeer . . . or a wreath . . . or a Christmas tree . . . until I was faced with making a single choice, and then I knew it was a star.

Because it sparkles, I suppose, and enchants the eye. It sheds light . . . and, perhaps, promise? And it plays a leading part in that Ancient Story that inspires our days for at least two months of the year.

Perhaps I am prejudiced, because tin makes such special stars. Whole galaxies of them! And no sooner do you reach the first than you are aware of thousands beyond.

If you have time for just one project this Christmas, make a tin star! And see where it leads you!

You can make stars from all parts of tin cans: from lids alone or from strips out of the sides or from the whole can cut in strips and radiating in spokes. You can attach more stars to the ends of the spokes. You can curl them, fringe them, crimp them, layer them, top the tree with them, and suspend them from the ceiling! You can even put them in your buttonhole!

SCANDINAVIAN STAR

One of the simplest and most effective stars you can make for a large tree consists of nothing more than strips of tin, cut from the sides of

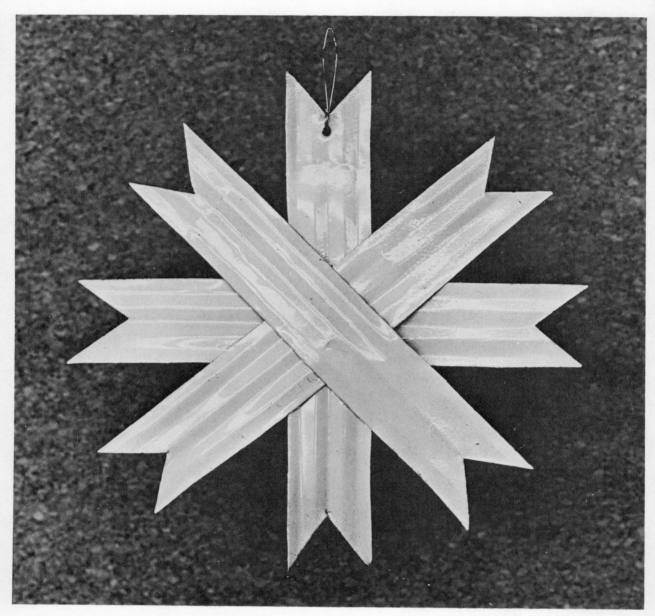

Basic Scandinavian Star

cans and glued together. In Sweden such stars are fashioned of straw, but the design lends itself beautifully to any can with ribbed sides. I will give you the basic formula for cutting and assembling the strips and then show you how you can vary the ornamentation on the ends of those strips.

Equipment
 Snips
 Hammer
 Awl

Materials
 Any shiny can
 Ruler and grease pencil
 Weldit Cement
 Krylon Spray Enamels—
 optional
 Dri-Mark pens
 Bottle caps and glitter

Remove lids, rims, and seam from can. (Refer to Techniques, if necessary.)

From the flattened side of the can, cut two strips ¾ of an inch wide and 8½ inches long.

Cut the strips in half and notch the ends (Fig. 1) to a depth of ½ inch, *except* for the one from which the star is to hang. Cut that end to a point and punch a hole in it with hammer and awl.

Glue the pieces together, two by two, with generous drops of Weldit or epoxy, placing one over the other like plus-signs: + +. (Score the metal where the strips cross for better adhesion.)

Let set for about five minutes until firm enough to pick up. Then glue one pair diagonally across the other so the spokes are evenly spaced and resemble an X sign over a + sign. Gently place a weight in the center. Let set overnight; then wire for hanging.

You can makes these stars all silver, or combine gold and silver strips, but possibly the most regal effect would be to hang all-gold stars on a royal Blue Spruce or Douglas Fir. If you should be asked to decorate your club for a Christmas party, you might consider placing a star-spangled tree in each corner of the room and suspending more Scandinavian Stars, large and small, silver and gold, from the chandeliers and the ceiling. Or, if the budget allows, you could spray-paint the stars in heavenly pastel shades so lovely with the soft blue of the trees. Or in tangerine and white—equally beautiful with those noble trees.

You can vary the basic Scandinavian Star design by trimming the ends of the strips differently and I'll show you four ways that have occurred to me.

Ornamentation of SCANDINAVIAN STAR Strips

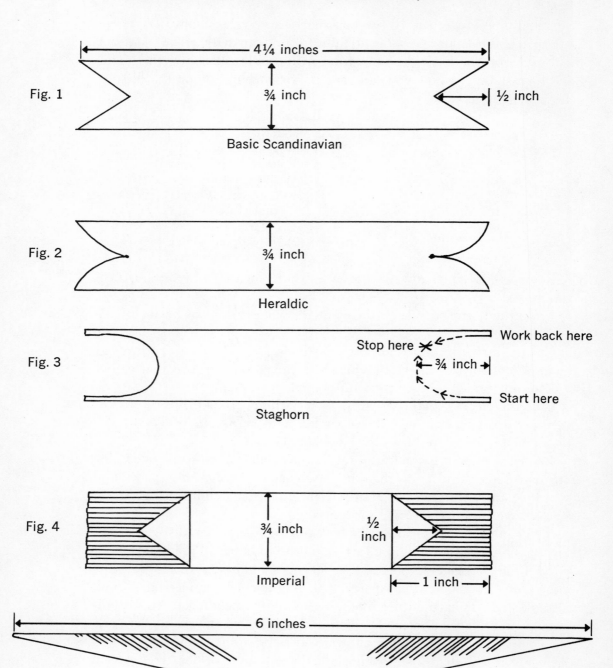

Fig. 1 — 4¼ inches — ¾ inch — ½ inch — Basic Scandinavian

Fig. 2 — ¾ inch — Heraldic

Fig. 3 — Stop here — Work back here — ¾ inch — Start here — Staghorn

Fig. 4 — ¾ inch — ½ inch — Imperial — 1 inch

6 inches — Porcupine

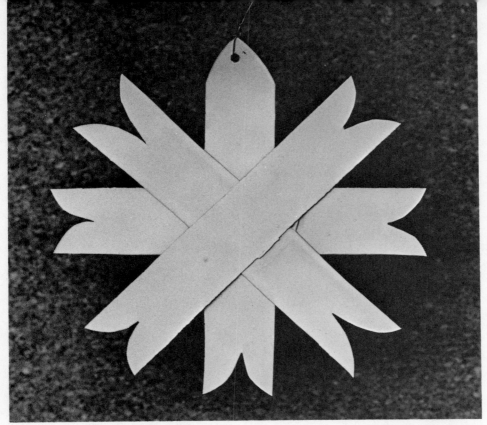

Heraldic Star—variation

HERALDIC STAR

What I call the Heraldic Star is notched with convex curves. I rather like this star: it has a romantic look. It puts me in mind of the Crusaders and their heroic trek across Europe to the Holy Land. And that reminds me of the first Christmas and how different it was from ours. And then I find myself trying to think of ways to recapture the spirit of the whole wondrous Christmas story.

One way to use the Heraldic Star would be to make a small one, no more than 1⅝ inches over all, and glue it to a 2½-inch shield. Paint the shield with Testor Insignia Red (or a sky blue) and make the star snow white. Very attractive on the tree!

Or create a wall plaque from a large Heraldic Star, cut from a 3-pound coffee can and measuring 14 inches overall, and glue or nail it to a large shield cut from sheet tin. Spray-paint star with Krylon Flat

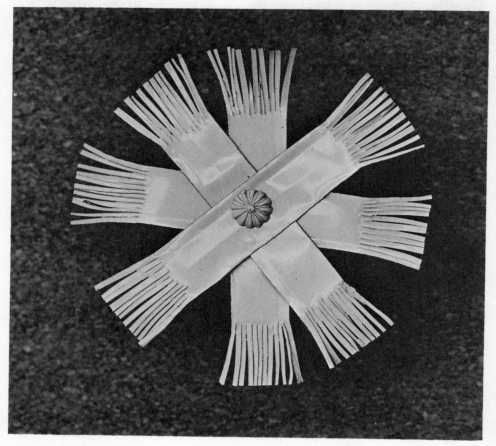

White Enamel; you'll like the purity of it against the pewter sheen of the sheet tin. Place the whole ornament on a square of oiled redwood or walnut.

FRINGED STAR

Another way to vary the basic design is to fringe it with serrated shears by making narrow 1/16-inch-wide cuts in the tips, 3/4 of an inch deep.

As I've mentioned before, I love fringe. It always makes me think of Mexico. Someday I am going to make my own version of a Mexican tree with gaily colored dolls (with fringed pigtails and feet) and adorable furry-looking burros (with fringed hocks and mane) and Eyes of God (with fringed tassels on all four corners) and shocking-pink and orange Fringed Stars! Won't that be fun?

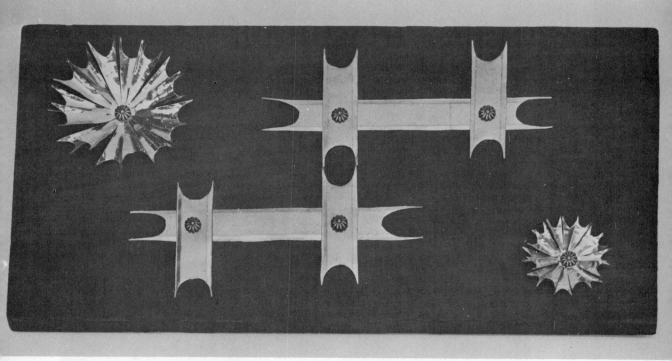

STAGHORN STAR

Still another variation of the basic design is the Staghorn Star, so-called because of the deep U's in the tips suggesting deer antlers. This silhouette makes such a perfect foil for more elaborate designs that I usually use it as a background rather than as an ornament in itself, but you can see from this plaque how simply it is made and how essentially decorative it is. You can also note how the star can be fashioned from the circular lids of cans, as well as the straight strips from the sides. But more of that later.

Cutting curves in tin is not quite so easy as it looks, but after a few awkward attempts, you'll get the feel of it. Start by sketching in the U's on each end of the four strips you have cut from the sides of the can, making sure that they are all the same depth.

Then do exactly as indicated in the preceding diagram (Fig. 3). As you go around the curve, use only the very tips of your snips—the last ⅛ inch of them—and move forward only ¹⁄₁₆ of an inch at a time. Keep your hand, and as much of the snips as is possible, *down under* the tin, so the little point you have cut curls up. Once around the curve, come down from the far side to meet it.

Hammer the antlers flat. Don't despair. You'll think nothing of it after a few go-rounds.

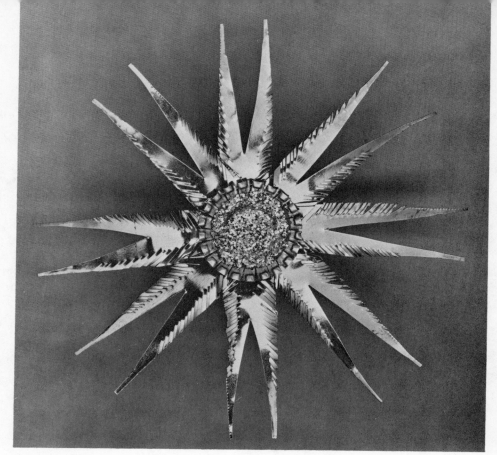

Porcupine Star—variation

PORCUPINE

The children and I devised this spiny star to take the place of the Polish porcupines that we had previously made of metallic paper. We had attached those paper porcupines to the tips of at least half the branches on our huge tree and the effect was absolutely smashing. We just adored them. Unfortunately, being made of paper, they got smashed, too, so we came up with this substitute.

They are made just like the basic Scandinavian Star (except that each strip is 6 inches long instead of 4¼ inches) with a glittered bottle cap in the center. Wire the star around the waist before you glue the bottle cap on. (Fig. 5, on the Ornamentation of Scandinavian Star Strips, shows you how to cut the tips, making a very deep V with angled fringe on the sides.)

You could make these Porcupines more prominent on the tree if you were to spray-paint them (or use bright Dri-Mark pens) before ornamenting. But even as unpainted metal strips, they add immeasurably to the overall sparkle of your tree.

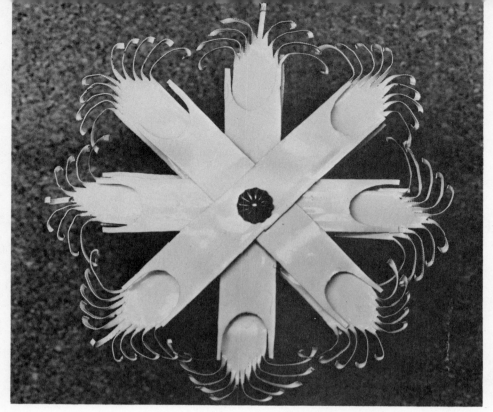

Two-sided Staghorn Imperial Star

IMPERIAL STAR

The Imperial Star looks complicated, but like many other designs, once you get the knack of it, it is idiot's delight to make and isn't it beautiful? It makes charming earrings, too, as you can see in Part Four, Trinkets for Gifts.

Start by drawing an equilateral triangle on the tin with a grease pencil, measuring the distances with a ruler so that all the ends are cut to the same depth. (For measurements, see Fig. 4, on the Ornamentation of Scandinavian Star Strips.)

Then follow the step-by-step photographs on the next few pages for curling the fringe on the Imperial Star.

Assemble the star as usual. Ornament the center with a Staghorn Star of some sort and place a gold Decora upholsterer's tack in the center.

I always like to combine the Imperial Star with the Staghorn; they make such perfect foils for each other. The one above I made two-sided (stuck together with Vogue Stikum) and spray-painted gloss white to hang over the center of a small dining table, set with gloss white plastic mats—perfectly pristine! So pretty with a centerpiece of white Michael-mas daisies!

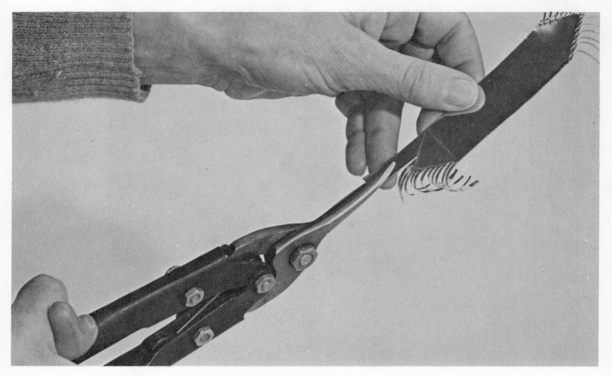

Imperial Star procedure:
(Above) With ruler and grease pencil, draw an equilateral triangle 1½ inches from each end of the four strips. Make 1/16-inch-wide cuts up to the triangles as shown. The last two or three strands will curl up, rather than down like the others. Smooth them back like the others by rubbing them with your thumb over your forefinger. (Below) Holding the base of the strands firmly with the fingers of your left hand, pull the first strand out to the right to form a shallow arch. Repeat with all strands up to the point of the triangle. Then, without turning the strips over, repeat the procedure on the left side of the triangle.

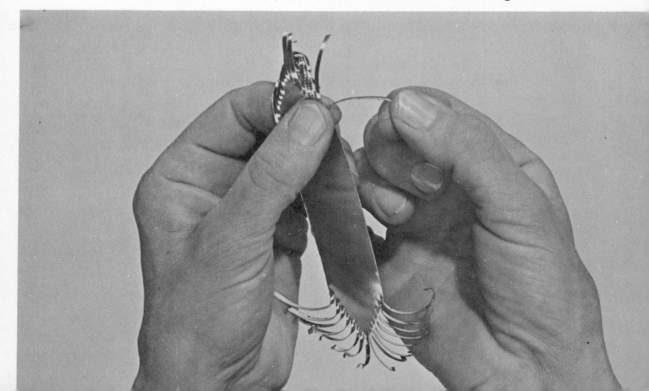

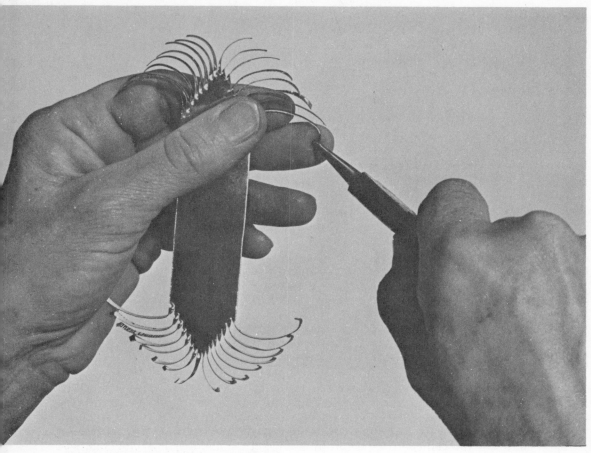

Imperial Star procedure (continued)
Above: To curl the strands on the right side of the triangle, grasp the very tip of each with the very end of the round-nosed pliers, outer wrist toward you. (Below) Execute the curl with a twist of your wrist, up and over, so your palm faces you.

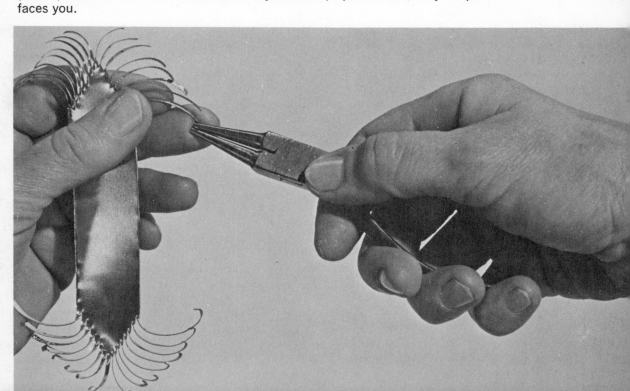

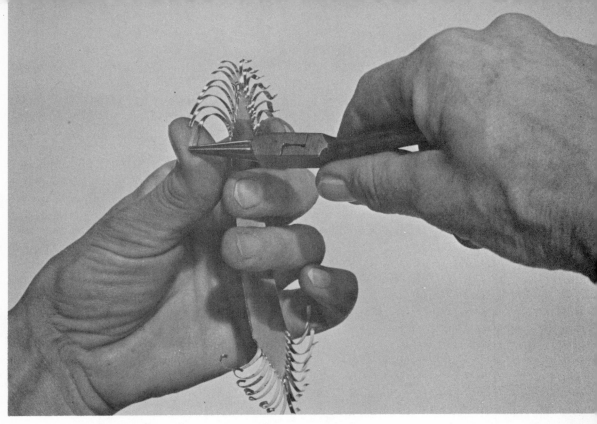

Imperial Star procedure *(continued)*
(Above) To curl strands on opposite side, turn strip over. Again grasp the very tip of each strand with the very end of the round-nosed pliers, outer wrist up. *(Below)* Execute the curl with a downward twist of the wrist. Notice in both operations how you can control the curl by steadying the pliers against the fingers of your helping hand.

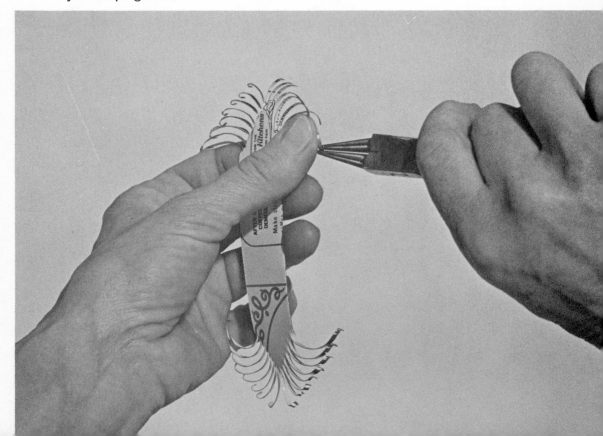

SWEDISH STAR

This star is also made from the side of a can, but out of a square piece rather than a strip. The original was whittled from a single piece of wood by nimble Swedish fingers, and the lovely feathery filaments are sliver-thin wood shavings. I have adapted the design to tin, and I think you'll enjoy its silhouette.

Equipment
 Plain snips
 Hammer
 Awl
 Ruler
 Lead pencil
 Long-nosed pliers

Materials
 Sides of cans (preferably unribbed)
 Krylon Gloss or Flat White
 Spray Enamel
 Architect's linen
 Carbon paper
 Ball-point pen
 Florist wire
 Decora upholsterer's tack
 Weldit Cement

The size of the can will depend upon the size of the star you wish to make, and that, in turn, will depend upon the place in your house where you want to use it. The large one in the center of my living-room windows (which run twenty-three feet along one end of the house) is twelve inches square. That had to be cut from sheet tin. The others, which hang from the garland along with it, vary from $3\frac{1}{2}$ inches to 6 inches and were cut from unribbed cans. (You *could* hammer a ribbed can flat enough to make it easy to mark and cut.)

I shall give you instructions based on a $4\frac{1}{2}$-inch square, which is average size. If you need a larger star, just make sure that its sides are evenly divisible by *three,* because you will have to divide them into thirds and cut out a wedge from the middle third.

Start by lightly spraying the entire flattened side of the can you have chosen with Krylon Flat White. (You can probably get two $4\frac{1}{2}$-inch squares out of it.) Cut the squares.

Mark off the sides into thirds, each third measuring $1\frac{1}{2}$ inches.

With lead pencil very lightly rule in the diagonal lines from corner to corner (Fig. 1). Rule in secondary lines $\frac{1}{16}$ of an inch to either side of those diagonals. (You will be cutting *up to* these secondary lines later.)

Freehand, draw a tiny $\frac{3}{8}$-inch circle in the center where the lines cross.

Put dots in the center of each section of the circumference. Draw

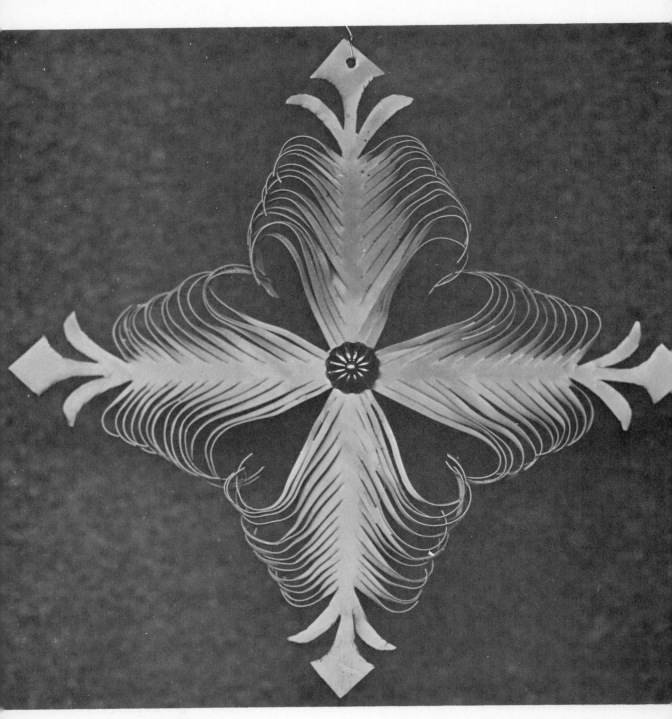

Swedish Star

lines *to* those dots from the two dots on each side of the square, thus forming wedges. Cut out the wedges.

Ornament the corners next by tracing the fleur-de-lis design onto architect's linen and transferring it to the tin with carbon paper and ball-point pen. (When enlarging the pattern, note that the fluer-de-lis uses a square ⅛ the length of the side; in other words, half of the thirds you have already defined. Eventually, you will simply mark off the square and draw in the pattern freehand.)

Cut out the fleur-de-lis, using the very tip of the snips (see Techniques) and straighten them with long-nosed pliers. If the points seem too sharp, nip them the tiniest bit.

Feather the shafts of the star by cutting ¹⁄₁₆-inch strips as shown (Fig. 2), first to the center circle, working up the shaft to the tip.

Cut out the little half moon under the fleur-de-lis last.

(Note: The strips will curl either more or less, depending upon the weight of the tin—more if it's tough and heavy, less if it's light. If you find the strips curling into tight little corkscrews, prevent them from doing it by putting the third finger of your helping hand in the way. You want *some* curl, of course, but you are going to have to pull them all up and tuck them into place under each other, and you might as well keep them in line as you go along.)

Cut down the right side of the shaft first, then the left. Do not turn the star over. You need the lines to go by. Cut all four shafts before straightening the feathers.

This star should be strictly two-dimensional, so you will have to flatten it by turning the feathers to the side. The photograph makes it pretty clear. Hold the base of the feathers firmly with thumb and forefinger of one hand while you turn the tips with the other. That will keep the star plumb.

Starting at the top, tuck each successive feather under the one before it. Fuss to form that pretty heart in each section.

When all done, respray the star lightly with flat white to cover pencil marks and make pristine.

With the wire-cutting device on the long-nosed pliers, cut off the shank of the Decora upholsterer's tack. Glue in place.

With hammer and awl, make hole for hanging wire.

A great variety of beautiful stars can be made from lids by dividing them into equal sections, ornamenting the tips, and turning them at angles. You will notice that the ornamentation is, in many cases, the

SWEDISH STAR

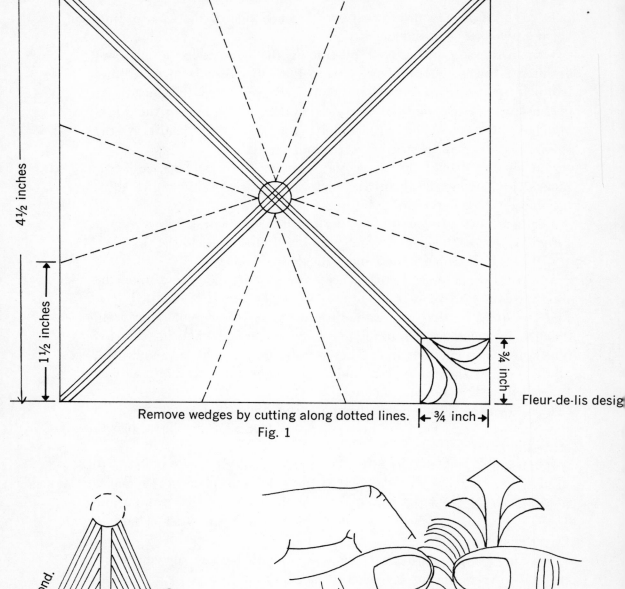

4½ inches

1½ inches

¾ inch

¾ inch

¾ inch

Remove wedges by cutting along dotted lines.

Fleur-de-lis desig

Fig. 1

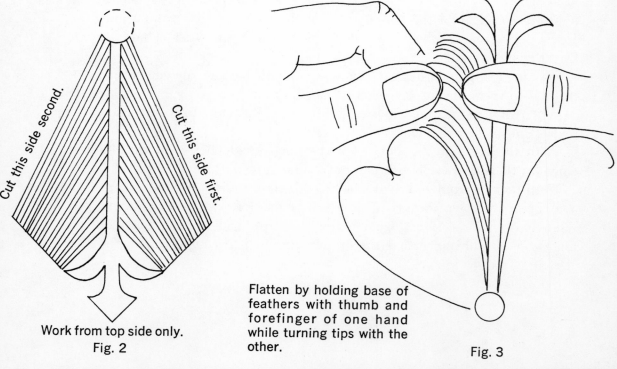

Cut this side second.

Cut this side first.

Work from top side only.
Fig. 2

Flatten by holding base of feathers with thumb and forefinger of one hand while turning tips with the other.

Fig. 3

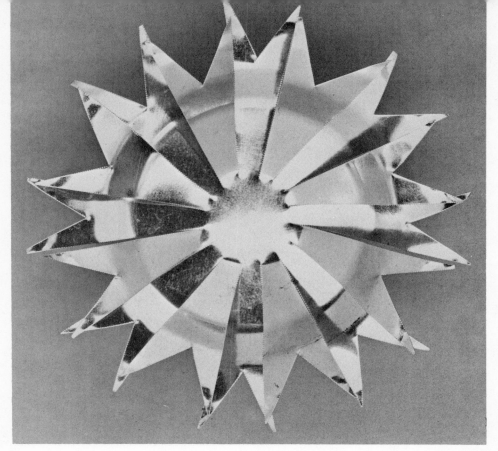

Sparkler

same as that for stars made from strips; that is notching, fringing, and making deep U's. Then I've added a number of curly confections as well. The Sparkler is a good one to start with and get you used to dividing a lid into equal sections.

SPARKLER

This is one of my favorites and I call it the Sparkler because it sort of shoots off in all directions like its namesake on the Fourth of July. Besides, it is so quick and easy and can be used in so many ways and sizes and colors.

Equipment
 Finely serrated snips for small ones
 or
 Coarsely serrated snips for big ones
 Hammer and awl—optional

Materials
 Lids (size depending upon use—
 Campbell's Soup good)
 Grease pencil
 Assorted Dri-Mark pens
 Rhinestones

SPARKLER
Diagram

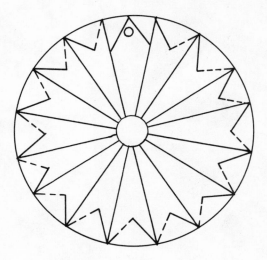

On one side of the lid draw a ¼-inch circle in the center with grease pencil.

Divide the lid into sixteen equal sections as follows: With serrated snips, cut *up to* the circle. Turn the lid around to the point on the circumference which your eye tells you is opposite the cut. Again, cut *up to* the center circle. You have now divided the lid in half.

Cut those halves in half. Then cut the quarters in halves. Then cut the eighths in halves. There! You have sixteen equal sections.

Now make bright, deep V's in the end of each section, *except for the one from which it is to hang*. Cut that to a point—and you'd better do it first, as you start each star, or you'll forget it.

However, you may not always want it to hang. If you will look at the Snowflake Tree, you will see that the Sparklers there, both at the top and in the rings, are *glued* on. If you will look at the Garland on the Little Christmas Tree, you will see that it is *strung* through its middle. But in the Sparkler Mobile, it *hangs*. The Sparkler would make a stunning tree-top star if cut from a 3-pound coffee-can lid, ornamented in the center with a bottle cap, resplendent with glitter. In that case, you would wire it across the middle *before* you glued the beer cap on.

As for painting the Sparkler, that again is determined by the use. I must admit I am partial to the pink and orange Dri-Mark on alternating sections with a "diamond" in the middle. See how delightful a contrast it makes with the green of the ivy on the Hanging Basket (Color Plate XIV).

SNOWFLAKES

Any small lid divided into eight or more sections, ornamented on the tips, and sprayed flat white, could be considered a snowflake. Alternate sections may be pushed forward or backward or turned to one side, but they should be uniformly structured because that is the nature of snowflakes. Here are a few suggestions to get you started (Fig. 1).

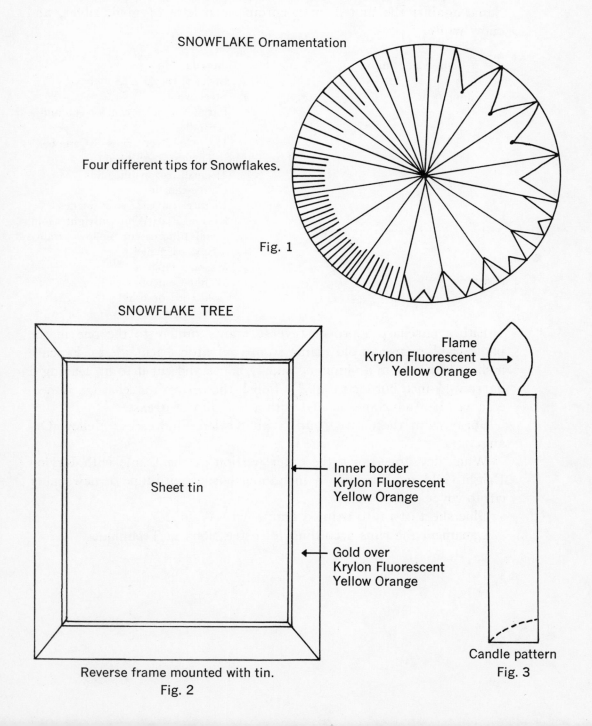

SNOWFLAKE Ornamentation

Four different tips for Snowflakes.

Fig. 1

SNOWFLAKE TREE

Sheet tin

Inner border
Krylon Fluorescent
Yellow Orange

Gold over
Krylon Fluorescent
Yellow Orange

Reverse frame mounted with tin.
Fig. 2

Flame
Krylon Fluorescent
Yellow Orange

Candle pattern
Fig. 3

SNOWFLAKE TREE

(Color Plate XI)

This tree was designed primarily to demonstrate the beauty of orna-
mented rims, but I've tucked it in here because of all the Snowflakes.
It has other appealing aspects as well, the most obvious of which is
symmetry and not the least of which is color. You will like the touch of
flame against the muted, monochromatic palette of gold, silver, and
snow white.

Plain-edged snips

Equipment

Materials
 Sheet of tin 20 x 28 inches
 Steel wool
 Large V-8 juice can for tub and
 candles
 15 gold-silver rims (Campbell's
 Tomato Soup ideal)
 15 small frozen-juice lids
 Coffee-can lid
 Picture frame 22 x 28 inches
 Krylon Flat White, Bright Gold,
 and Fluorescent Yellow Orange
 Spray Enamel
 Masking tape
 Weldit Cement
 Gold cord or braid

Either purchase a proper reverse frame similar to the one in the
photograph or use an old frame from your attic, back side to. Procure
a sheet of tin from a plumbing supply house and cut it to fit, leaving a
narrow ¼-inch border (Fig. 2). Polish the tin with steel wool, if nec-
essary. (It often comes coated with a fine film of grease.)

Spray-paint the entire frame with Krylon Fluorescent Yellow Or-
ange.

When dry, tone down the outer portion of the frame with Krylon
Bright Gold, masking the ¼-inch inner border with tape or newspaper
cut to cover.

Glue sheet of tin to painted frame with Weldit.

Ornament the rims according to instructions in Techniques.

Cut Snowflakes, and spray-paint with Krylon Flat White Enamel. You may prefer to have your Snowflakes all alike, in which case the Sparkler makes the best pattern, I think. Remove two sections from the coffee-can Sparkler where the candle goes.

From the flattened sides of a V-8 can (used rich gold side out) cut a tub to measure 4½ x 5¼ inches. Notice that the wide border forms the top of the tub. Curve the piece just a little to suggest the roundness of a tub.

From the same V-8 can cut nine candles and a tree trunk (Fig. 3).

Place candles in a row on a sheet of newspaper, with another sheet of paper masking the body of the candles, and spray-paint the tips with Krylon Fluorescent Yellow Orange.

Before gluing in place, position all the pieces on the background, measuring distances to be sure that everything is properly centered.

Leave everything in place and proceed to glue, starting with the tub. You may want to make a tiny scratch mark with the awl right next to the edge of the tub to indicate where to replace it. Do the same at the tip of each candle. The placement of the rims is obvious.

Follow the instructions on the tube of Weldit Cement for making proper contact, tackiness, etc. Where the areas of contact are very narrow, as with the tub and the rims, apply cement consistently along the edges, but not in such quantities that it will flow out onto the tin background. However, if it does, leave it there! Do not try to remove it. It is transparent and will show less than rub marks.

In gluing the candles, you will need only a thin line down the center. Leave the flame free. It casts a little shadow and adds a realistic touch. As does the third dimension of the Snowflakes. If you look, you can see that they are glued on only at the center. Pull some sections farther forward than others, but make sure that the centers make good contact with the metal background. Score the backs of the Snowflakes for better adhesion.

All that remains to be done is to glue on the gold cord or braid. I had gold cord so I used it, but braid would be easier both to put on and to procure out of season. It makes a nice finishing touch to the framing, confining and defining the narrow flame border.

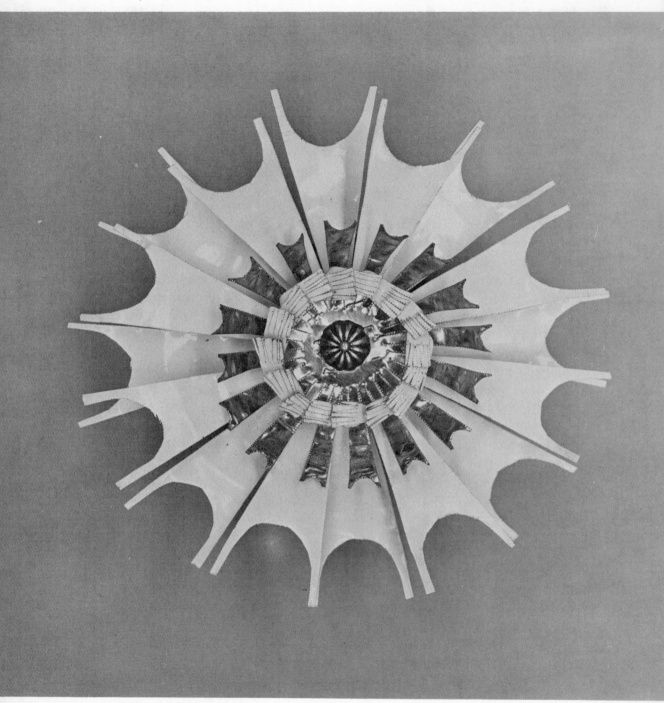

Staghorn Circle with Fringed Whorl

STAGHORN CIRCLE

The Staghorn Circle is nothing more than a lid divided into sixteen equal sections, the tips of which are ornamented with a U. If you haven't already made one according to the basic Scandinavian Star design, you might look there for help with cutting the U. As you can see from the Staghorn Wreath (Color Plate IV) it makes a very distinguished ornament when decorated with a Fringed Whorl.

FRINGED WHORL

The Fringed Whorl is also made from a lid divided into equal sections, usually thirty-two. After fringing each tip, take the circle in your right hand, thumb in the center to hold the base of the sections firm. Then, with the thumb and forefinger of your left hand, curve one section up and twist it to the right. Proceeding counterclockwise, curve up every other section, twist it to the right, and lay it on the one before it. Ornament center with upholsterer's tack.

This makes a beautiful center for any of the other stars, or for a larger Fringed Star like the enormous one on the Fringed Wreath (Color Plate VII). It is even quite nice just by itself, especially if you form Gothic arches from the outside strands on each section by turning them toward each other. (Fringed Whorl Pin under Trinkets for Gifts.)

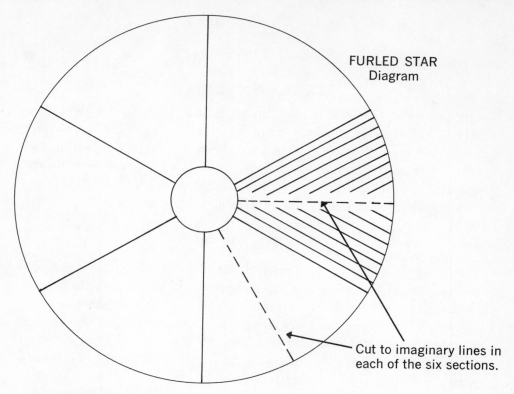

FURLED STAR
Diagram

Cut to imaginary lines in each of the six sections.

This star may be cut with plain or coarsely serrated snips, or even kitchen shears.

FURLED STAR

This is marvelous for moppets.

Equipment
 Snips (coarsely serrated if you
 have them)
 Hammer and awl (optional)

Materials
 V-8 juice lids are handsomest
 Wire
 Ruler and grease pencil
 Protractor (optional)

With ruler and grease pencil, divide the lid into six sections. (That would be every 60 degrees if using a protractor, but your eye would do almost as well.) Cut along the lines to within a dime's worth of the center.

Freehand, draw a line with grease pencil down the center of each section. Cut as indicated in the diagram to within $\frac{1}{16}$ of an inch of that line.

Work around the piece clockwise, cutting first down the right-hand side and then down the left-hand side of each section. Keep the fingers of your helping hand out of the way so the strips can curl as much as they like.

Once all the way around, rub off any traces of grease pencil remain-

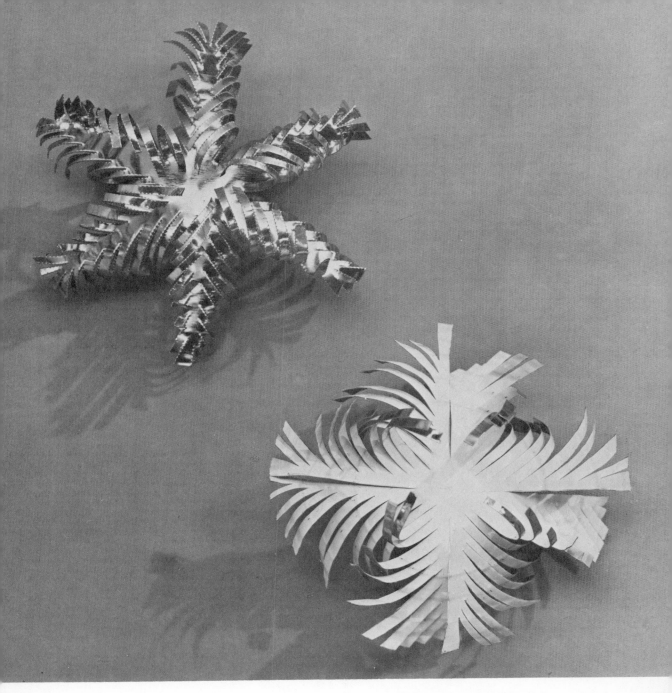

Furled and Unfurled Stars

ing and push the strips so they curl over the center mark where the line
had been. Turn the star over and do the same on the other side.

Make a hole in one tip for wiring or simply bend back a tip to form
a hook. You can make umpteen in no time.

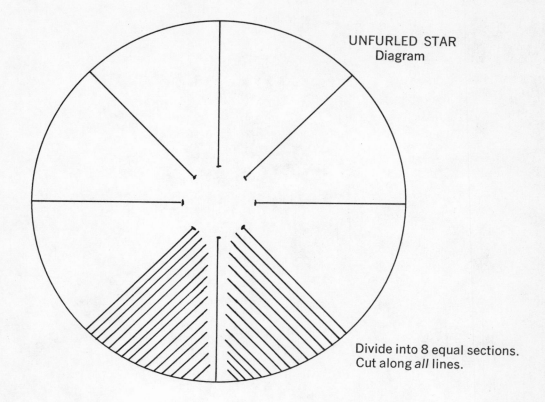

UNFURLED STAR
Diagram

Divide into 8 equal sections.
Cut along *all* lines.

UNFURLED STAR

The diagrams for the Furled and Unfurled Star look so much alike, one has to study them to see the distinction, and yet, as you can see, the finished ornaments are quite different in mood.

Equipment
 Plain snips
 Hammer
 Awl

Materials
 Any 4-inch lid with bright gold
 lining
 Krylon Gloss White Spray Enamel
 Wire

Spray-paint the silver side of the lid with Krylon Gloss White Spray Enamel. Let dry.

Divide the lid into eight equal sections, first in half, then in quarters, then in eighths, by eye.

Cut as shown in diagram.

With hammer and awl, make hole in one tip, and wire for hanging.

(You don't *have* to paint it, of course.)

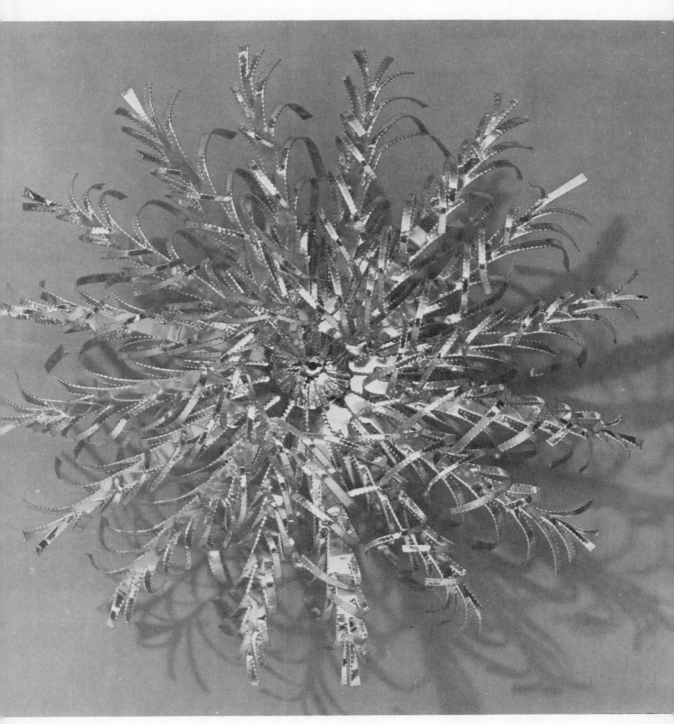

Frosty Star

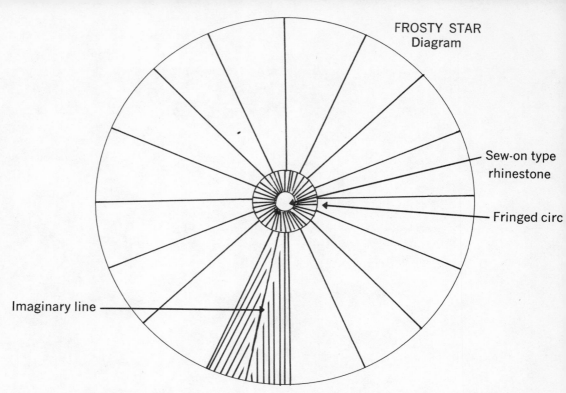

FROSTY STAR
Diagram

Sew-on type
rhinestone

Fringed circ

Imaginary line

The Frosty Star has 16 sections; cut with coarsely serrated snips.

FROSTY STAR

This one vies with the Sparkler for versatility of use and popularity. You will find everyone exclaiming "Oh, I love *that* one, but, *my*, it looks complicated!" Actually, it isn't complicated, but you *must* have those coarsely serrated snips.

Equipment
 Coarsely serrated snips
 Long-nosed pliers

Materials
 All-silver lids (most coffee can lids
 ideal)
 Grease pencil
 Rhinestones, sew-on type
 Weldit Cement

Divide the lids into sixteen sections just as you did for the Sparkler. (When I use any *large* lid, I am quite apt to draw in the first four dividing lines with grease pencil, just to be sure that I get the important cuts straight, but after that, I divide the sections by eye.)

Cut strips down each side of an imaginary center line in each section (see diagram). That's all there is to it!

A few bits of advice:

Work around the lid *clockwise,* in other words, to the left.

Keep the fingers of your helping hand out of the way so that the tin

can curl *down* underneath, on the right side of the section, and *up* on the left side.

If the up-curving strips on the left don't curl to please—and for some reason they don't always curve as evenly as those on the right—curl each one after you cut it, very gently and naturally with your fingers. You will notice that the strips have a tendency to corkscrew to the right. Encourage them to do this. Not only does it form a nice whorl, but it also helps to avoid putting creases in the curves.

If, when you are all through, you think the tips look a little coarse and blunt, (because the coarsely serrated snips could not cut them finer without bending them) just split the tip of each section with your *finely* serrated shears.

The star is pretty dazzling as is, but I like to heap riches upon riches and place a "diamond" in the center. So I cut a small circle the size of a quarter out of a scrap of tin, and fringe it. Score the back of it and also the center of the star where the two will touch. Apply glue to both pieces and allow it to become tacky. Push the fringed piece into place. Then glue the rhinestone in the very center.

I recommend the sew-on rhinestone, incidentally, because it is more brilliant than its flat-backed cousin and also much easier to handle. You may need the long-nosed pliers to put it in place, however, because the star is so deep in curls.

The most spectacular use to which I've put this Frosty Star is the Christmas Comet. The entire tail is made of nothing else and the effect is really scintillating. But for all its brilliance, the Frosty Star is so exquisitely made and essentially refined that it can play a complementary part as well as the leading role. In the Treetop Star, for example, even though it is literally the center of interest, it takes nothing unto itself, but serves to augment and enhance the prevailing laciness of the total design.

Then, too, if cut from a lid of richest gold, it can even be worn as a pin. It is actually elegant enough!

TREETOP STAR

Undoubtedly the most spectacular stars are to be made from cans whose sides have been divided into equal sections and bent out horizontally so that they radiate in spokes from the circular center formed by the end of the can. You will find an easy method for doing this in the section on Techniques. Such is the Treetop Star. This one was made with a relatively shallow sweet potato can, and even so it measures eight

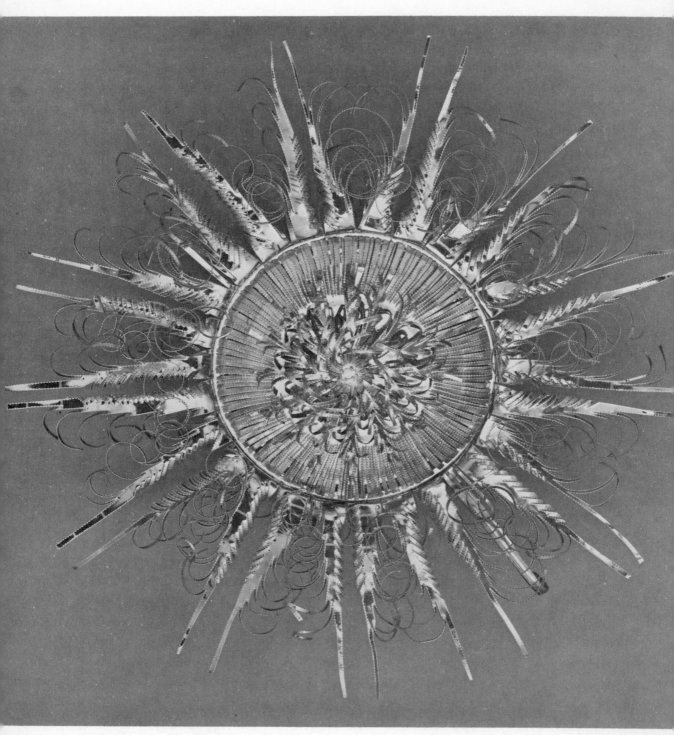

Treetop Star

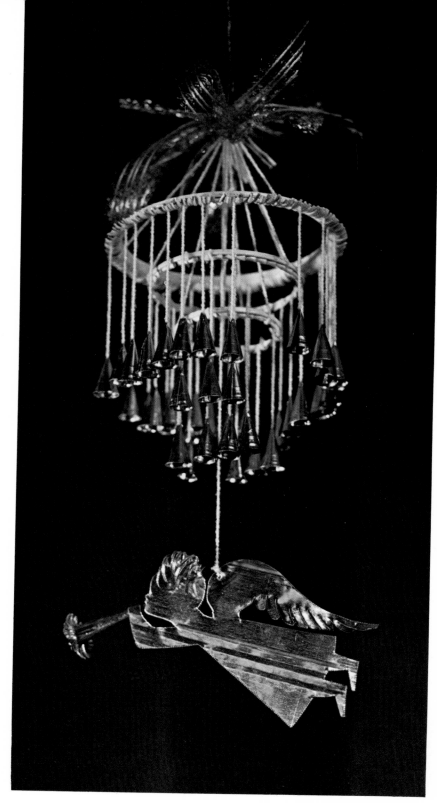

II—Trumpeting Angel Wind Chime

inches across. Plenty large enough for the top of even a ten-foot tree. Imagine how stunning it would be if made from a large V-8 juice can which is three times as deep! Or from a 3-pound coffee can which is as tall as a V-8 juice can and two and a half times as wide across. And then visualize what an effect could be obtained if you were to add more stars to the tip of each spoke.

I will give you the general procedure for making the Treetop. After that you will find yourself on your own.

Equipment	Materials
Coarsely serrated snips	1 *whole* (gold and silver) can, in-cluding top
Round-nosed pliers	
Ball-pein hammer	1 Frosty Star for center ornament
Awl	Weldit Cement
Chopping bowl	Florist wire

Leave the can entire except, of course, for the top lid which you have already removed in opening, and perhaps the top rim, which you might find difficult to cope with the first time you try to make this kind of star. (Later you may very well leave it on from choice.)

Cut sides into approximately equal ½-inch sections. (See Techniques if necessary.) Open out horizontally. Make two holes ½-inch apart in the center of the can end and wire for hanging. (Twist the wires in the back to get them out of your way while you ornament the star.)

In ornamenting the spokes, treat every two adjoining sections as a unit and cut as indicated in the diagram.

When all the spokes have been cut and curled gracefully, either with your fingers or the round-nosed pliers, ornament the center by fringing the top lid to a depth of 1½ inches.

Place the fringed lid in the chopping bowl and beat it with ball-pein hammer until it conforms to the shape of the bowl. (See Techniques.)

Apply Weldit Cement to the inside tips of the fringe, and glue, domed side up, in the center of the star.

Glue Frosty Star to the center of the dome.

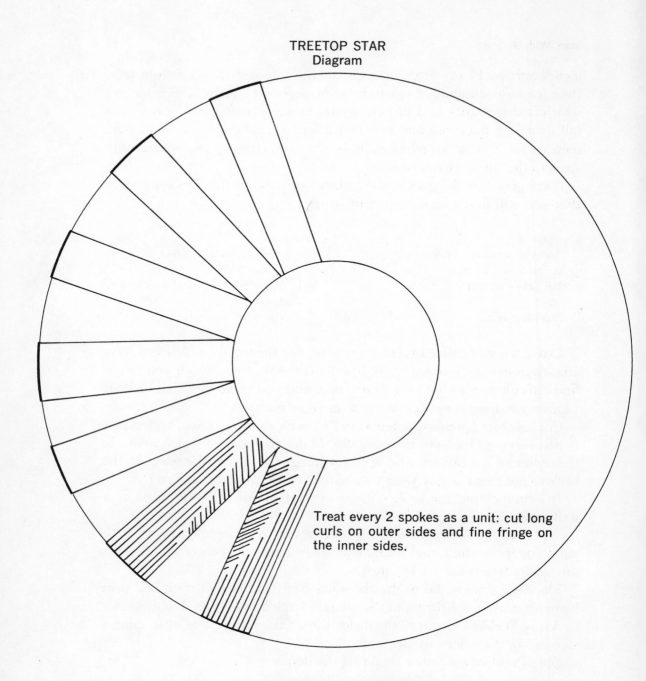

TREETOP STAR
Diagram

Treat every 2 spokes as a unit: cut long curls on outer sides and fine fringe on the inner sides.

CHRISTMAS COMET

Perhaps you, too, are one of those people who go off to exotic places and come back with your suitcase crammed with treasures you don't know what to do with.

So it was with me and this coconut palm frond—until one day it occurred to me what a natural comet it could make with that plummeting

curve and the squiggly tail. And how beautiful crusty silver stars could be against the bleached wood. So I made a large Treetop Star for the comet itself (and glued it on to the end of the stick with Weldit!). I cut up another can, as I had for the Treetop, and used the spokes all along the stem. And the squiggly tail I scattered with all sizes of Frosty Stars, gluing the calyxes of the coconuts into the star centers and rhinestones in the centers of the calyxes. Can you see from the photograph? (Unfortunately, it doesn't begin to give you a sense of the dimensions—the Comet is 5 inches deep and 3 *feet* across—or the brilliance.) Those other little brown centers are pine cones of some sort that grow all over the Florida Keys.

Which reminds me that I later realized I could have made the same thing with a Red Pine branch from my own back yard, but I had just never thought of it! It was right there, and I didn't *see* it. Pine cones, cut cross-wise, would make beautiful rosettes for the centers of stars. What an idea for a swag!

Christmas Comet

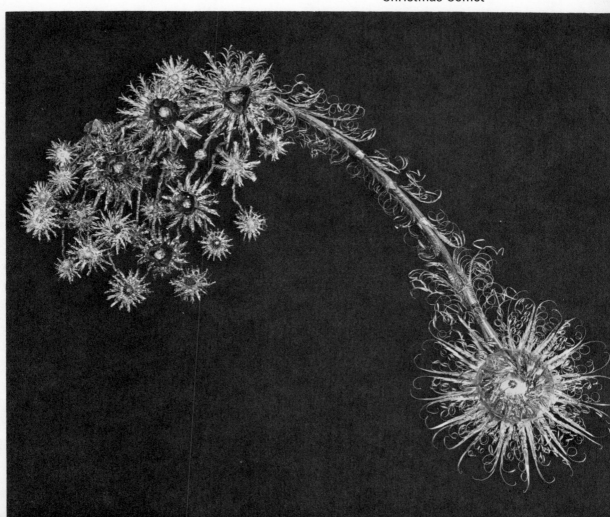

FRUITS AND FANCIES

In the last few years a trend has develop for each household to have not just one, but two trees for Christmas—a formal one in the living room, a fun one in the family room. The formal one quite intentionally abandons variety for the sake of elegance and close harmony with the existing color scheme. It is fastidiously festooned with opulent ropes of gold tinsel, studded with ornaments of one design and one color, and strung with color-coordinated lights. It is frequently all blue or all pink, occasionally two-toned blue and green, but is seldom more complex than that, sacrificing diversity for dignity.

While this glistening prototype satisfies the mistress of the house, the children clamor for a "real" tree, an old-fashioned tree that is a riot of color and loaded with every imaginable ornament. Each year, with shining eyes and impatient fingers, they unpack the boxes of ornaments stored in the attic, and, teetering on the stepladder, strew them about the scented fir. (The tree *must* smell, that's essential!). And to replace the inevitable casualties and camouflage the tree completely, they plunge merrily into pots of paste to make more ornaments for the collection. Creativity is, after all, the very substance of Christmas! However, in the interests of permanence, you might encourage your own darlings to try their hand at some of the simple tin fruits and fancies which follow.

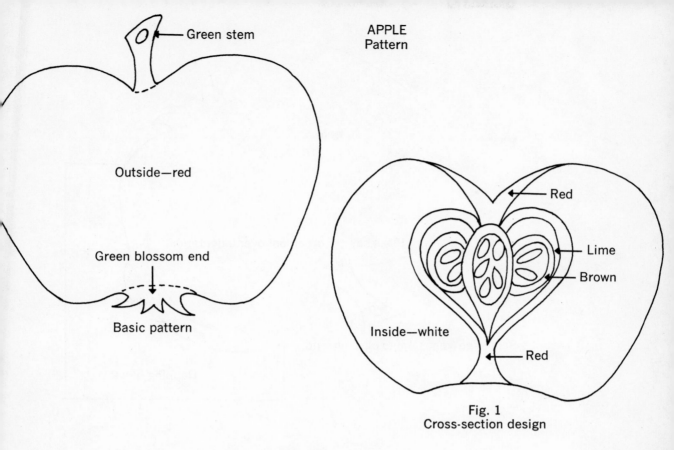

Green stem

APPLE
Pattern

Outside—red

Green blossom end

Basic pattern

Red

Lime

Brown

Inside—white

Red

Fig. 1
Cross-section design

APPLE
(Color Plate IX)

Equipment
 Plain-edged snips
 Dapping block or chopping bowl
 Ball-pein hammer
 Awl

Materials
 $3\frac{1}{2}$-inch (or larger) lids
 Architect's linen, pencil, and scissors
 Rubber cement
 Dri-Mark red and green markers
 (orange, pink, brown optional)
 Fine wire
 Vogue Stikum or Posey Clay

Cut the Apple

Trace the pattern onto a 4-inch square of architect's linen. Cut out the pattern and apply with rubber cement to the lid. Follow close to the edge of the pattern as you cut out the Apple.

Watch out for rough edges as you remove the pattern and rub off cement.

No matter how painstaking you have been, you will find the outline needs improving. So hammer the edges; trim them smooth; and, using the very tip of your snips, clarify and prettify the curves.

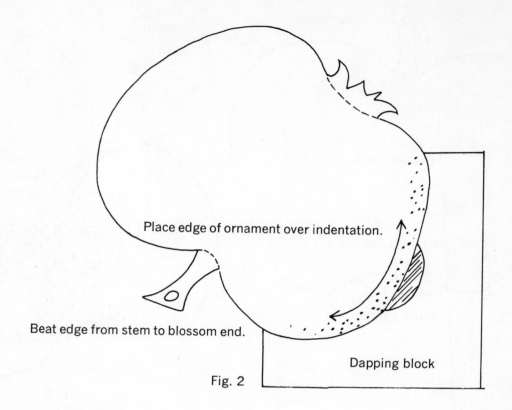

Place edge of ornament over indentation.

Beat edge from stem to blossom end.

Dapping block

Fig. 2

I like to exaggerate, rather than minimize, the blossom end; it lends so much character. But if you find it impossible to execute, eliminate it altogether and make a bottom like the one in Fig. 1.

If you think you'd like to add leaves to the stem end, you will have to cut the ornament from the *sides* of a can where you have plenty of tin to work with.

Shape the Apple

You don't *have* to shape the Apple, of course. The concentric circles in the lid provide a ready-made, stylized design that is quite attractive, and if you are in a hurry, you can color the Apple and be done with it. But the beaten Apple really looks good enough to eat. The fine hammer marks actually resemble the speckles in the skin and the plump curve is convincingly luscious and juicy. It's well worth the extra bit of fussing.

Whether you have a proper dapping block or only a chopping bowl, place the round edge of the Apple against the bottom of the bowl (Fig. 2) and with fine hammer strokes, beat around the edge to the stem end, then back around to the blossom end. Continue moving back and forth around the curve until you reach the center. Then turn the piece around

and work to the center from the other side. Do not beat the stem or the blossom end. And don't hurry! That will put creases in the edge which you will only have to hammer out. Creases are all right in a mushroom, but not in an apple. Make *very* fine hammer marks, *very* close together, and you will produce an Apple as tempting as Eve's.

It's optional, of course, but rather fun—since it is technically only *half* an apple—to simulate the cross section (Fig. 2). It need not fit perfectly; the discrepancy between the inside and the outside will make a good dark border for your design.

Spray-paint the piece white.

Sketch the design in lightly with pencil. Then color as indicated with fine-point, felt-tipped, oil-based pens.

Fix in position with Vogue Stikum or Posey Clay. (Roll the clay between the palms of your hands to make a short worm. This will hold just as well as a round ball and weigh less.)

Paint the Apple

Here again you have a choice. If it amuses you to recall the Fall of Troy and the Golden Apples of Aphrodite, you will want to make your Apples from lids with a rich gold lining, and paint only the stem and blossom end green. But if you fancy a Paradise Tree, as they did in the Middle Ages, you will want to paint your Apples bright red, with stem and blossom end green. The easiest way to do it is to use Dri-Mark red alone, or in combinations of red and pink, or red and orange, or red and brown, squirreling them around till they blend. But whichever combination you choose, make all the Apples alike in order to get a really stunning effect.

Iridescent nail polish is good, too, for that very special friend who thinks all's right with the world as long as there's pink! It provides the rich transparency of enamel. So does the metallic paint made for model cars, etc. (It is put up in small jars and is purchasable in hobby shops and stationers'.) But the quickest and easiest is the felt marker.

With awl and hammer, make the hole for hanging. Then, with a 6-inch length of fine wire, make a loop. Squeeze it together and feed first through the hole in the Apple, then through itself—like tags on new clothes. To avoid damaging my jade plant I bend the wire over the branch like a hook, but on the Christmas tree, I open the loop and hang it on the tip of the branch in the conventional fashion.

Incidentally, these Apples make pretty gift tags for presents, as do many of the Trifles for the Tree, and are in themselves a sort of "bonus" gift.

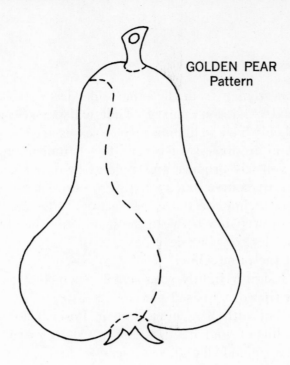

GOLDEN PEAR
Pattern

. . . and a GOLDEN PEAR

Equipment
 Plain-edged snips
 Ball-pein hammer
 Screwdriver
 Dapping block or chopping bowl
 Awl

Materials
 3½-inch lids (or larger) with rich
 gold linings
 Architect's linen, pencil, and scissors
 Grease pencil
 Rubber cement
 Green felt marker or white oil paint
 Fine wire

The Golden Pear is made much like the Apple except that it has *two* cheeks! But that's no problem. Trace the pattern (Fig. 1) onto architect's linen and cut out. Apply rubber cement to the lid and pat the pattern in place. Cut carefully around it. (Here again, eliminate the blossom end if you can't maneuver it, but it adds a great deal.)

Sketch in the dotted line on the tin with a grease pencil and define that curve by tapping the screwdriver along its length.

Then beat the Pear on the silver side in the dapping block or chopping bowl just as you did the Apple, starting at the outer edge and working with fine hammer strokes toward the center. Don't beat the stem or blossom end.

Beating the tin will curl the Pear up like an autumn leaf. Restore it to its proper pear shape by holding it with both hands, top and bottom, curved side toward you, thumbs on top in the middle. Then with an

inward twist of both wrists and a push with your thumbs, bend it straight again. It will crease in a pleasant, naturalistic curve across the middle. Isn't it nice?

Paint the stem and blossom end with green felt marker or with white oil paint—if this is your year to be all gold and white. I painted some of mine russet, with green stem and blossom end. They were lovely and juicy-rich.

CHRISTMAS ONION

The onion is a classic Christmas ornament and lends itself perfectly to the conformation of the lids of tin cans. It can be just as easy or as complicated as you want to make it.

Equipment
 Finely serrated snips
 Coarsely serrated snips
 Ball-pein hammer
 Awl
 Chopping bowl or dapping block
 (for some)
 Glove

Materials
 Assorted shiny lids 3½ inches or
 larger—for onions
 Small frozen-juice lids—for centers
 Bottle caps, preferably gold with
 clear plastic linings (Schaefer)
 Posey Clay or Vogue Stikum
 Rubber cement
 Weldit Cement
 Architect's linen, pencil, ruler, and
 scissors
 Hair wire or tinsel cord
 Upholsterer's tacks, thumbtacks,
 brilliants, glitter, etc.
 Dri-Mark pens
 Talens Glass Paints
 No. 1 sable brush

Cut the Onions

Place a 4-inch square of architect's linen, dull side up, over pattern in book and trace, using ruler to square off top. To make absolutely symmetrical, fold traced design in half and cut out.

Apply rubber cement to lid. Center pattern over concentric circles in lid. Rub until pattern adheres—the ridges in the lid make complete adhesion impossible.

Cut out carefully. You want a continuous, flowing line, no corners. (Good idea to wear glove on helping hand.) The curves at the neck and tip are the only tricky places, and you will probably have to go over them after removing the pattern to clear them of the little "hangnails."

Christmas Onion—Schaefer's Pride

Hammering the hangnails helps. Try to make the neck nice and narrow.

Ornament the Onions

Here's where the fun begins. The possibilities are limitless. In general, make both sides of the ornament as much alike as possible; it looks better in profile that way. Try the different golds in the lids and bottle caps in different combinations to see which are happiest together. Here are some suggestions:

SCHAEFER'S PRIDE

Cut ornament from shiny gold-and-silver lid. Trim and hammer around edges where necessary to make true.

For a center, fringe edge of Schaefer bottle cap by making short, cuts between ridges. Hammer cap gently on label side just enough to open it out but not flatten completely. Glue, cup up, in center of onion.

Make hole at top of ornament with hammer and awl, and wire for hanging.

SCHAEFER'S BEST

In this the bottle cap is domed, which gives a certain importance and richness to the design.

Cut the Onion from a shiny gold-and-silver lid. Trim.

Fringe two 2-inch lids (one silver, one bright gold) ¼-inch deep with coarsely serrated snips. Hammer flat. Glue in center of each side of onion, silver against gold and vice versa.

Fringe two bottle caps by cutting between ridges.

Hammer flat on board on label side.

Place in chopping bowl, lining side down, and hammer gently until bottle caps are perfectly cupped.

Secure, domed side up, in center of ornament with a ball of Posey Clay or Vogue Stikum.

Make hole with hammer and awl, and wire for hanging.

KICKAPOO JOY JUICE ONION

I like the Schaefer bottle cap best because it's perfectly beautiful just as it is, but *any* cap will do if you put glitter on it. Unfortunately, glitter has a way of looking cheap, but on the other hand, it does catch the light and if used with discrimination, can be quite effective.

Proceed as previously, cutting the design from any shiny lid, etc.

Fringe any bottle cap. Cover just the cork (or gray plastic lining) with either gold or silver glitter, depending upon which looks best with the metal in the fringe. Don't let any of the cork show, but don't make the mistake of glittering the fringe! Glue in place.

Christmas Onion—Schaefer's Best

Kickapoo Joy Juice Onion

I give you the above design because it "will do" when you want an effect in a hurry. But a better way to use glitter is in the beaten Stardust Onion, below. Silver glitter against the rich gold of some lids can be quite lovely, and when that gold is beaten to give it dimension the result is almost royal.

STARDUST ONION

You will need a proper dapping block for the Stardust Onion because the center dome is raised above a flat field, and you can't get that effect in a chopping bowl.

Center ornament over the smallest, shallowest indentation in the dapping block (Fig. 1). With the ball-pein end, hammer from the *center out* until the tin conforms to the shape of the bowl. The depression should be entirely covered with tiny hammer marks.

Move on to the next larger (about 1½ inches) *shallow* bowl in the dapping block. Probably, this one will exactly fit one of the circles marked on the tin which will help as a guide and keep the ornament centered. Tap the tin gently at first and then harder, until it fully conforms.

To finish the dome move to a third bowl in the block which has the same circumference but is deeper. Hold the ornament firmly and finish the job carefully, outlining the circumference clearly with well-aimed hammer marks. Flatten the "field" if necessary with the other end of the hammer, but try not to "ball pein" the field. You want the contrast of satiny, hammered metal against a flat shiny field.

Now give dimension to the edge of the Onion by placing it in the center of the shallowest, smallest die and tapping it gently with the ball-pein hammer (Fig. 2). Work around the curve in both directions, but stop short of the neck and tip. They should remain flat, like a sort of resolute plumb line.

Once beaten, the Onion is ready to be glittered. You may like it so much plain you won't want to add anything. But Christmas *is* sparkly and perhaps one should add the glitter. In which case, apply the glue (which comes with the glitter and is pure white and perfectly beautiful against the rich gold and gives you still another "idea") only to the beaten surfaces, making as clean a delineation as possible.

Then add glitter. When dry, dust off the excess.

Inasmuch as you have just made one side of the Onion convex, you have at the same time made the other side concave. To make them look alike, attach a convex medallion to the back side of the ornament by

CHRISTMAS ONION
Pattern

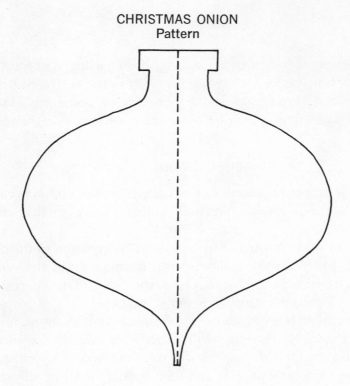

STARDUST ONION
Diagram

Dapping Block

Dapping block

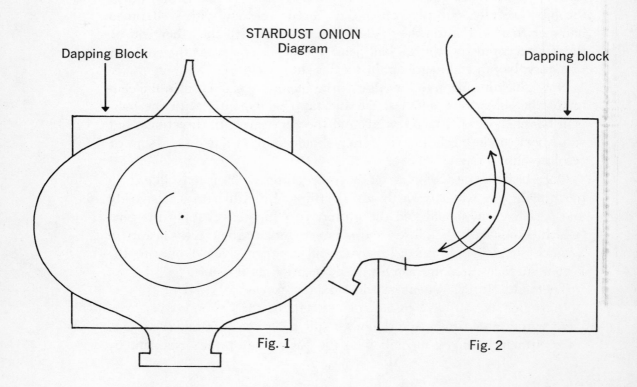

Fig. 1

Fig. 2

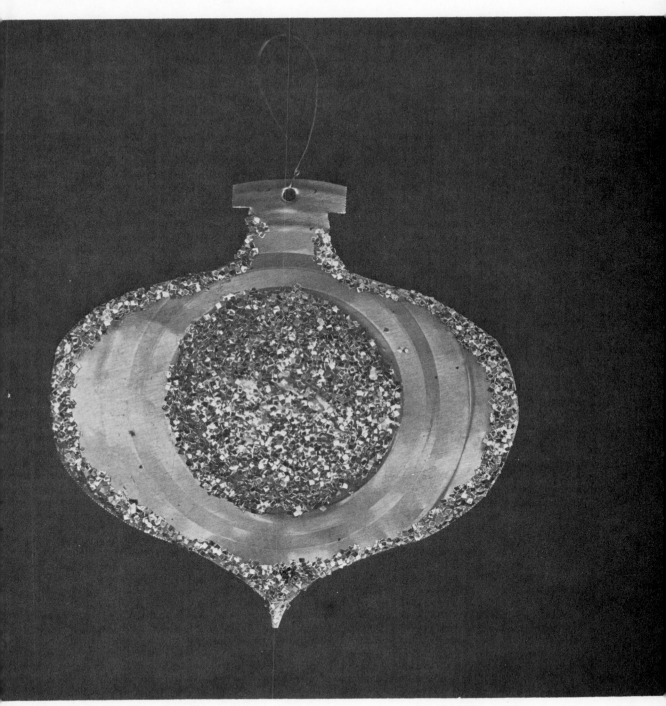

Stardust Onion

fringing a 2-inch frozen-juice lid (or else a cut-down larger lid of just the shade of gold you find pleasing) and beat it, as you did the Onion. Flatten the fringe as the piece lies in the die. Apply Weldit Cement to the underside of the fringe and the part of the Onion where the medallion will rest. Wait for a few minutes and press in place.

Apply glue and glitter in the same fashion as you have on the front. The two sides are not identical, but look fine in profile.

Painting the Onions

Coffee can lids lend themselves nicely to the Christmas Onion, but because the brand I use has writing all over one side, I spray-paint them white and ornament them with black and gold. If this is too sophisticated, use any color combination you like. As a general procedure, I usually define the outline with a fine line drawn all the way around the edge of the Onion in about ⅟₁₆ of an inch. Then I make concentric circles in the center, drawing around quarters and dimes and add dots and cross-hatching and scrolls just to amuse myself. I offer you some designs to follow in case it should happen to amuse you, too. I use both the felt markers and the glass paints for this. Be careful to hold them by the edge while you're working. (See Color Plate XV.)

FROSTY STAR ONION
(Color Plate XV)

You can also make Onions from the sides of cans. This one, which is too plain to please my children but which I adore, is made from the pale-gold, ribbed tin of a creamed corn can. I have beaten it around the edges just a little and have hung a Frosty Star from the tip. The fineness of the rib, the softness of the gold, and the delicate serration of the star contribute an elegance that you might expect to find at Tiffany's or Neiman-Marcus. It is a true treasure.

MEXICAN SUN
(Color Plate IX)

Equipment
 Finely serrated snips
 Hammer
 Awl

Materials
 Shallow cans 2½ inches in diameter
 with gold linings
 Plain paper for pattern
 Rubber cement
 Grease pencil
 Krylon Crystal Clear Spray Lacquer
 Architect's linen

III—Angel Sconce

IV—Staghorn Wreath

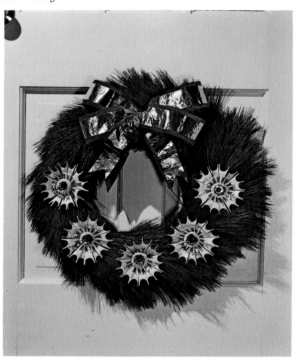

V—Kissing Ball

VI—Advent Wreath

VII—Fringed Wreath

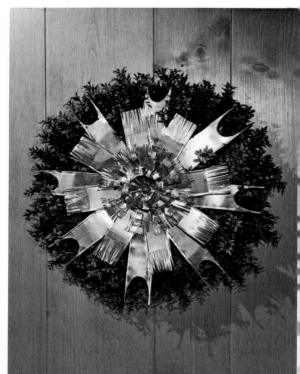

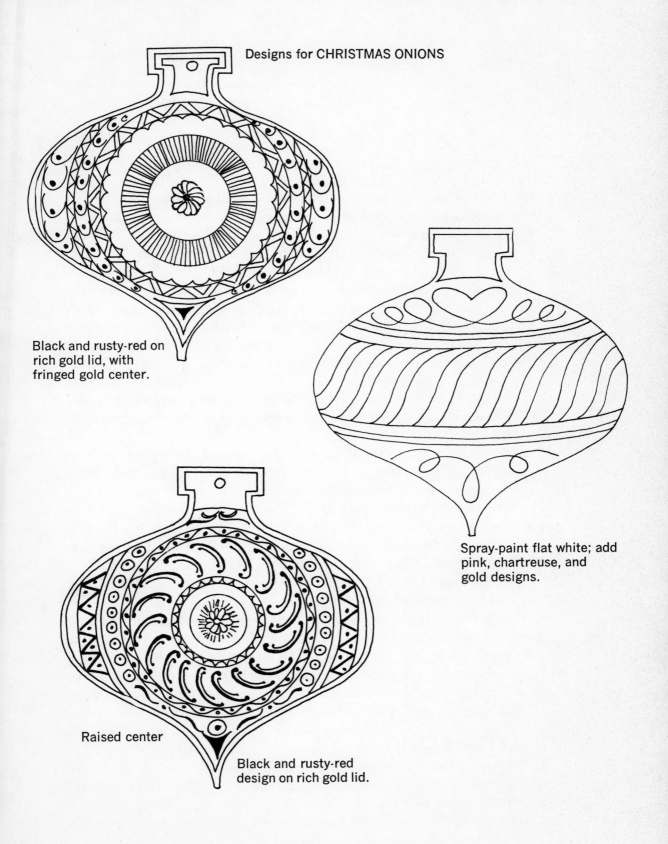

Designs for CHRISTMAS ONIONS

Black and rusty-red on
rich gold lid, with
fringed gold center.

Spray-paint flat white; add
pink, chartreuse, and
gold designs.

Raised center

Black and rusty-red
design on rich gold lid.

Carbon paper and ball-point pen
Talens glass paints
No. 1 sable brush
Hair wire
Dri-Mark pens

This smiley Sun is so cheerful, either as a trifle for the tree or as a tag on a Christmas present, that you may want to make a number of them. In which case, do each operation on all of them at the same time. The whole process will go along more efficiently, and among other things, your paint won't dry out from being left open too long.

A small deviled ham can is ideal for this ornament, but if you don't feel you can eat enough of that spicy mixture to provide you with all the cans you need, the Goff Cat Food can will do nicely instead—and I don't know any cat that won't eat all you will give him of that beef liver! Just make sure to open the end that says For Finicky Cats on it, because you will want to use the plain end for your ornament.

In opening either of these cans, *remove only the top lid and rim,* leaving the rest of the can intact. The ham can is just right as is, but you will have to cut down the sides of the Goff can to make them ¾-inch high.

Cut a piece of paper to fit around the sides of the can. Fold it in half three times, creasing well. Apply rubber cement to the sides of the can and pat the paper pattern in place on it (Fig. 1).

Cut along the creases with snips, thus dividing the can sides into eight equal sections. Carefully peal off the paper and excess cement.

With grease pencil, divide each section in half and sketch in the licks of flame, one short and one tall (Fig. 2). Cut out with snips.

Bend the flames forward with your fingers, so they stick straight out sidewise, and hammer the ornament flat on both sides.

You are now ready to paint. If you are able to sketch in the face *freehand,* with grease pencil or awl, you can happily save yourself the trouble of tracing the pattern from the book onto architect's linen and transferring it to the tin with carbon paper. Otherwise, you will have to go through that process, first spraying the gold side of the tin piece with Krylon Crystal Clear lacquer, so that it will accept the carbon paper imprint. (Use a ball-point pen to transfer the design; for some reason a pencil won't work.) *Trace only the essential features* of the face onto the tin: the eyes, brows, nose, and mouth. You can improvise the ornamentation on the cheeks and forehead, painting it in freehand; it is too intricate to come out clearly in the tracing.

In painting the face, start with the dark blue, doing first the pupils

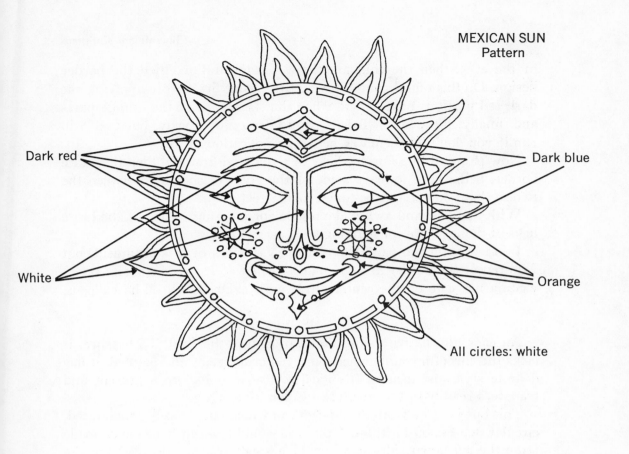

MEXICAN SUN
Pattern

Dark red

Dark blue

White

Orange

All circles: white

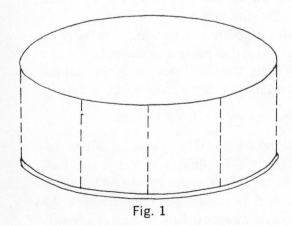

Fig. 1

Mark off paper pattern and paste onto can. Cut can along lines to rim.

Fig. 2

Remove paper and excess paste. Divide sections and sketch in short and tall flames with grease pencil.

of the eyes, then the chin and brow ornamentation, then the border design. Do this on *all* your Suns. Let the paint dry before applying the dark red portions next. Then, when that is dry, paint the orange parts and, finally, the white. (Talens paints dry quite quickly, but they will run if you don't let them dry between applications.)

Now paint all those merry licks of flame, red first and then the white border, being sure to leave some of the gold tin showing between the two so that you get a three-toned color effect.

With hammer and awl, make a hole for hanging in one of the large licks of flame. Wire for hanging.

I do not bother to paint the face on both sides of this ornament, but I do repeat the border and the flames. Then, if it is to be a gift tag, I write a message on the center circle with a Dri-Mark oil-based pens.

SEAL

An easy alternative to the Mexican Sun is the Seal. To be sure, it lacks the cheerful countenance, but even crudely cut and painted, it has definite style and drama. It's ideal to use in doing up a present and transfers readily to the tree. (See Color Plate IX.)

This one is made from the lid of a can which has a nicely pronounced, circular depression in it, but I think it would be even handsomer made from the cut-down sides *and* end of a small frozen juice can (in the style of the Mexican Sun). It would then be half an inch larger overall. and have the added textural interest of the rim.

Unless you intend to spray-paint it before decorating, be sure to choose a can with colors you like, and use opaque model enamels for any additional ornamentation, rather than the transparent glass paints. Make the slits for the ribbon with hammer and screwdriver.

PRAYING ANGEL

This charming creature was designed by Mrs. Douglas Mirk, resourceful and ingenious mother of six, whose Christmas tree is trimmed entirely with her original designs in tin. Made from the lid of a Portuguese sardine can, the Praying Angel not only perfectly utilizes the conformation of the can, but conveys its message directly and eloquently in the best primitive tradition.

Equipment	Materials
Plain snips	Oval Portuguese sardine can lid
Long-nosed pliers	Architect's linen, pencil, and scissors
Hammer	Rubber cement
Awl	Krylon Flat White Spray Enamel
	Florist wire

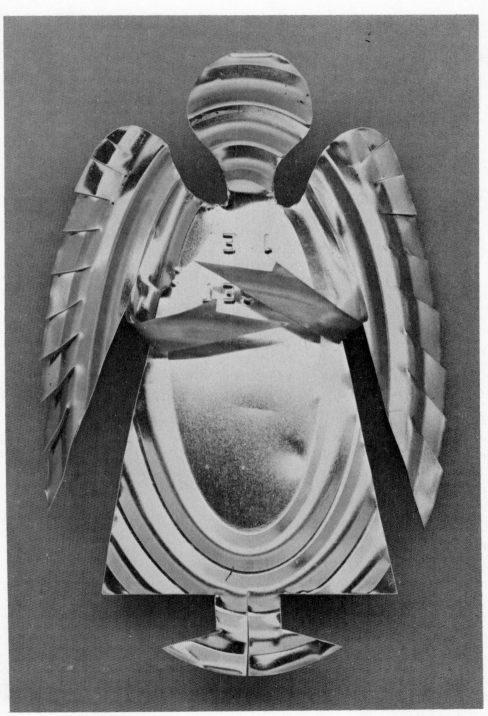

Praying Angel

PRAYING ANGEL
Pattern

Fold

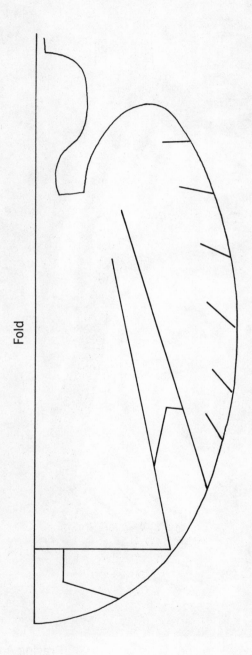

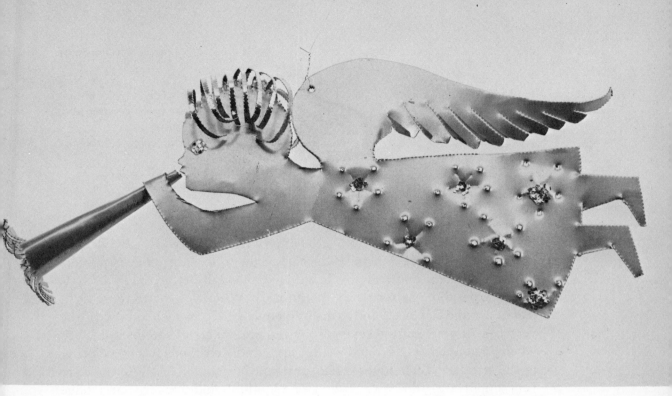

Trumpeting Angel

Trace design from book onto the dull side of suitably sized piece of architect's linen. Fold and cut out.

Apply rubber cement to surface of lid. Position pattern and cut out. Spray-paint the tin.

Fold arms. Bend wings. With long-nosed pliers, turn down metal tab at top of head.

Spray-paint again. With hammer and awl make a hole and insert wire for hanging.

See what an enchanting sconce she makes (Color Plate III) when haloed and framed by the rest of the can.

TRUMPETING ANGEL

If you have already made little Penobscot Indian Wind Chime bells, this Angel should not prove too difficult, although even so, the trumpet is not easy to form with the Angel's hand attached. However, it seems better to me to have the whole ornament in one piece than to bend the Angel's hand to fit a separate bell and glue the two together. If worst comes to worst, use the alternative angel which is completely flat. After all, she has only one wing, so why not a flat trumpet? It is nice, however, to add that third dimension if you can.

Equipment
 Finely serrated snips
 Round-nosed pliers
 Long-nosed pliers
 Hammer
 Awl—optional

Materials
 Can sides with bright gold linings
 —unless you want to paint her
 Brilliants or glitter
 Architect's linen, pencil, and scissors
 Rubber cement
 Braid or rickrack—optional
 Hair wire

Trace design from book onto the dull side of an oblong of architect's linen. Cut out carefully and apply to flattened side of can already covered with rubber cement. (The can need not be plain, since ribs make a nice ornamentation running lengthwise through her.)

Cut around the pattern very fastidiously. When you get to those tight places around her neck and arms, take only little $\frac{1}{16}$-inch cuts with the very tips of your snips, keeping your snipping hand well *under* the work when you are cutting around to the right, and well *above* it when cutting to the left (see Techniques). Her innocent brow and pert little nose are very important—do be careful. Her mouth should pucker, but I have found that too difficult. One protruding lip will do. Cut the feathered part of the wing out in a single great sweep on the first go-round. Go back later and cut the notches, etc.

Once cut, hammer her flat, cut off the little unevennesses, and generally improve her outline.

Next, form the trumpet, following the instructions for the Penobscot Indian Wind Chime bells. You will find that shaping the bottom of the bell is no problem, but turning the top is complicated by the presence of her hand and her head is in the way. I cannot accurately describe how you will have to pinch with the round-nosed pliers and poke and push with your fingers, and flip the whole figure over in an effort to roll the trumpet into a cone, and on down her arm, so that it comes into position before her mouth and appears to be held in her hand. This procedure takes *instinct*. Even if I could tell you how to do it, and you could watch me do it, you'd still have to rely on instinct and common sense. Do not be discouraged. You *can* do it. And she will reward you for years!

Fringe her trumpet about $\frac{3}{8}$ of an inch.

Define feathers in wings by clipping and cutting as indicated. Then, with thumb and forefinger, shape the wing into a slight S curve, from shoulder to tip, to lend dimension and grace.

As for her hair-do, be fussy about cutting those strands. Make them

TRUMPETING ANGEL
Pattern

Fig. 1 Angel with rounded trumpet

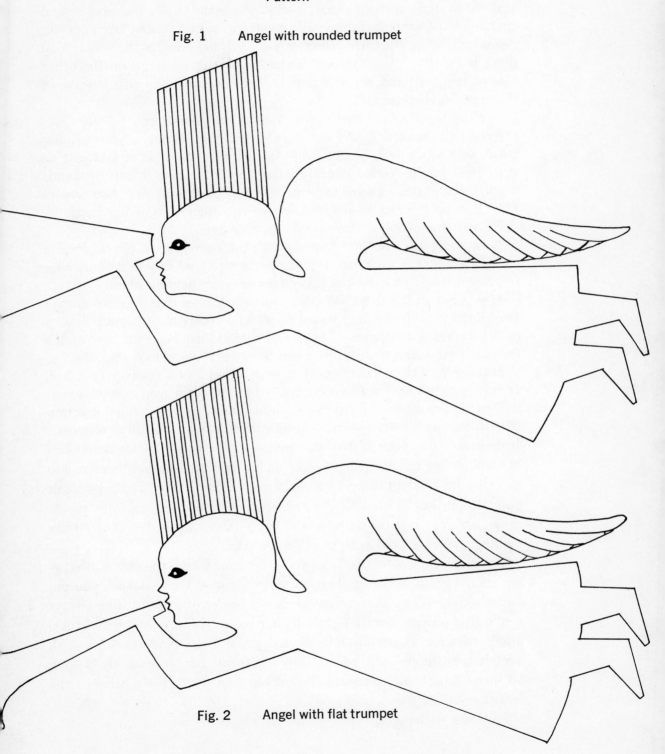

Fig. 2 Angel with flat trumpet

just as straight and equal as possible. As you cut, let the first strand curl *down under* with the snips. *Prevent the second* strand from curling down by holding the third finger of your helping hand in the way. (You don't want that strand to curl under because it must go on the other side of her head and you will only have to uncurl it to make it wave in the opposite direction.)

Let the *third* strand curl down, but *not* the *fourth,* etc.

When all the strands are cut, *part* her hair. Hold her in your helping hand, feet to the left, head to the right. Leave the first strand just as it is. Pick up the second strand by the tip and smooth it until it stands erect. Smooth it *backward with your thumb over your first two fingers* until it curves perfectly smoothly down the other side of her head.

Repeat this process with every other strand.

Now *shape* her bouffant hair-do with the round-nosed pliers, curling each lock under in an S curve (see photograph) while you hold its *base in place at the part with the forefinger* of your helping hand.

If you get a kink in any of them, just remember that you can always *straighten* it with the *long*-nosed pliers and recurl it with your fingers or the round-nosed pliers. That's one nice thing about tin; unless it's cut too narrow and breaks off, it can be reworked and look like new.

Having been to the beauty parlor, your Angel is now ready to be robed. If you have cut her from an ungrooved piece of tin, you can ornament her with stars made of glitter or with brilliants, or you can paint primitive little flowers on her skirt, or glue gold rickrack or braid as a border. It depends upon your taste and where you are going to use her. I left her completely unadorned (except for her diamond eye) when she was to swing under the little gold wind chime (Color Plate II), but I made pinpricks in her skirt with the awl another time (see working photograph above). But on the tree she might show up better if she were painted a lustrous red with gold fringe trim.

Not until she is "dressed" can you determine where the hole for hanging should go in her wing, because the weight of the materials you put on her skirt, will make a difference in her center of gravity. I've always found that picking her up lightly by her wing with my thumb and forefinger tells me where the hole should go, but a string stuck on with Scotch tape should tell you exactly. Suspend her from quite a long (8 inch) length of hair wire so that she can float freely between the branches of the tree.

Isn't she enchanting?

JUMPING JACK
(Color Plate IX)

Isn't he gay? I can't quite figure out why such a Harlequinesque character has such a minstrel-mouthed smile, but it doesn't matter, he cheers me up. He's a copy of an old English one which was even more ornately painted, but he would be equally amusing cut from a black and white coffee can, planned so the lettering was unrecognizable and his face painted white. Then the fussy work would be eliminated. On the other hand, the fussing *can* be half the fun!

Equipment	Materials
Plain or finely serrated snips	Flattened side of a coffee can
Ball-pein hammer	Architect's linen, pencil, and scissors
Round-nosed pliers	Ruler
Long-nosed pliers	Grease pencil
Awl	Rubber cement
Dull kitchen knife or penknife	Florist wire
	Coat thread
	Talens glass paints (optional)
	Krylon Spray Enamel
	Bead or little bell
	Decora upholsterer's tack

Trace pattern from book onto the dull side of an 8 × 8-inch piece of architect's linen folded double on the right in order to make two arms and two legs in one cutting. Be sure to mark the large and small circles for awl holes. Cut out.

If you are going to use the lithographed design on the coffee can, play around with the pieces to see what interesting decorative effects you can get. It can be quite an absorbing puzzle.

Once you have decided exactly where you want the pieces to go, make a little mark as a guide with grease pencil. Coat the space with rubber cement, and pat the pattern in place.

Continue in this fashion from piece to piece until all are in place.

Cut out carefully, trying not to touch the pattern.

Before removing pattern from pieces, make holes with hammer and awl, right through the linen. Get them right, or Jack won't jump!

Remove patterns, rub off excess cement. Turn pieces over and go into the holes again, with hammer and awl, to open them up. Then hammer them flat and smooth on both sides.

If you are going to paint Jack as I did, now is the time to do it—before you assemble him. Spray-paint him a solid color first; then proceed as suggested in the drawing, or make up your own design using Talens glass paints.

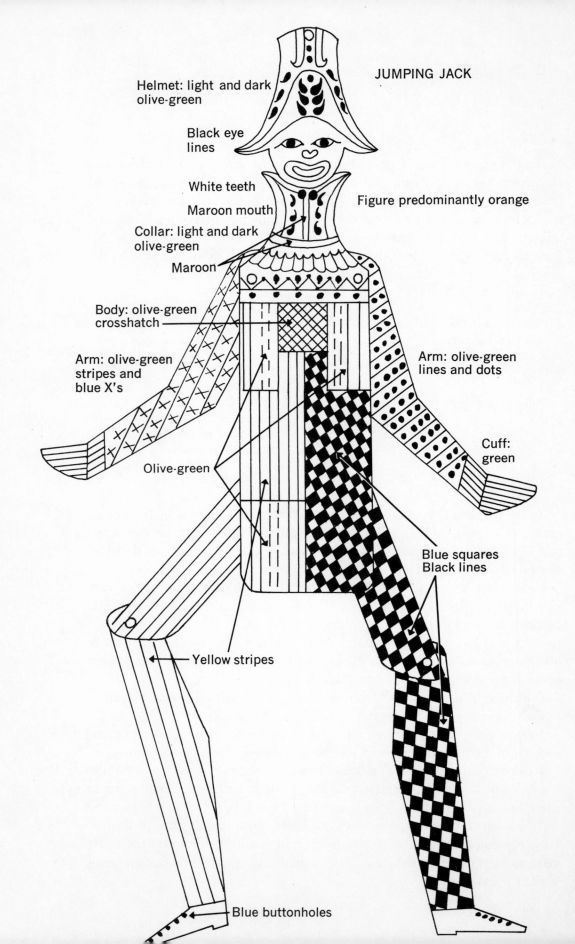

JUMPING JACK

Helmet: light and dark olive-green

Black eye lines

White teeth

Maroon mouth

Figure predominantly orange

Collar: light and dark olive-green

Maroon

Body: olive-green crosshatch

Arm: olive-green stripes and blue X's

Arm: olive-green lines and dots

Cuff: green

Olive-green

Blue squares Black lines

Yellow stripes

Blue buttonholes

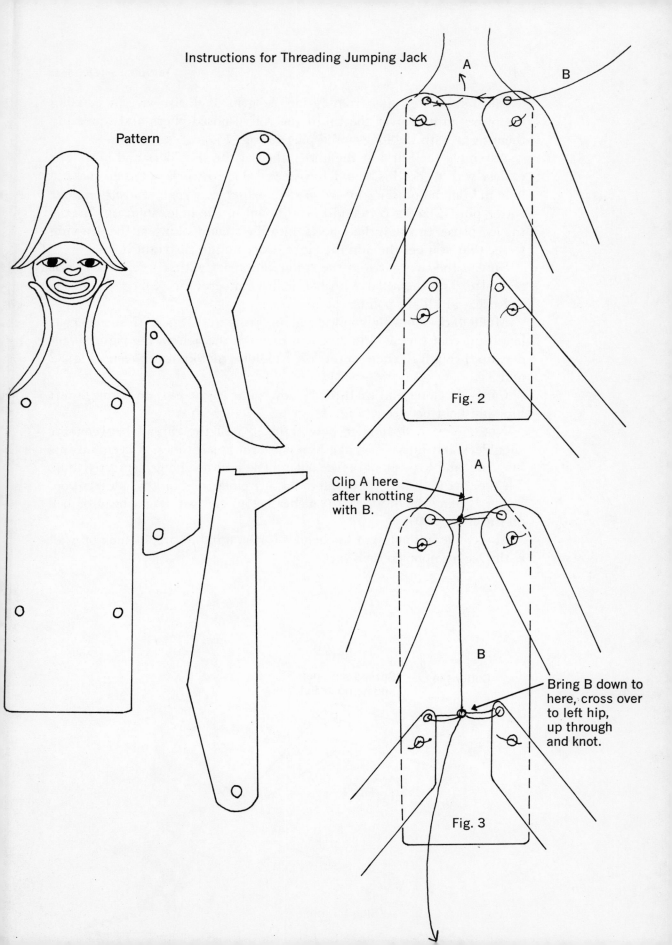

Instructions for Threading Jumping Jack

Pattern

A

B

Fig. 2

Clip A here
after knotting
with B.

A

B

Bring B down to
here, cross over
to left hip,
up through
and knot.

Fig. 3

Form six cotter pins from ⅞-inch lengths of florist wire by bending the pieces in half over the tip of the round-nosed pliers and squeezing them tight with the long-nosed pliers (Fig. 1).

Assemble Jack first at the knees, then at the shoulders and hips. The easiest way to do this that I have been able to work out is to make a hole in your hammering board *just the right size for the head* on your cotter pins. Place a cotter pin head down in the hole, stem up. Impale the leg pieces through their holes onto the stem, looking at the drawing to see that you get them in the right order and in the right holes.

Spread the two wires in the cotter pin apart with a kitchen knife or penknife. Tap them flat with ball-pein hammer (Fig. 1).

Repeat at all six points.

Make Jack jump by connecting his arms and legs with a generous length of coat thread. Put A down through the hole in the right shoulder, up through the hole in the left shoulder, and knot between (Figs. 2 and 3).

Carry B (long end of thread) down into right hip, up through left hip, and knot between (Fig. 3).

Note: You will wonder how tight to pull the thread between the shoulders and hips. To make him cheerful at all times, it seems to me his arms and legs should stick out a little and not hang perfectly limp. Tie the thread tightly enough to hold them in a position that pleases you.

Let B hang down at least 6 inches below his feet. Tie a bead or bell on the end.

Make hole in the top of his helmet for hanging. Wire, or tack on wall with Decora upholsterer's tack.

Cotter pin Spread pin open
 and hammer flat.

Fig. 1

Glue Strip

Cut on fold
of linen.

BRIGHT BIRD

Nothing in nature, except light itself, is as bright as a bird. This little fellow is particularly sprightly because he was made from a beer can which was lithographed in Christmas colors: white, green, gold, and red. What could be more ideal for our purposes when Christmas is upon us and time is short? Surely the tree should sing with birds!

Equipment Materials
 Finely serrated snips Sides of cans lithographed in
 Hammer Christmas colors
 Awl
 Architect's linen, pencil, and scissors
 Rubber cement
 Weldit Cement
 Green glitter and glitter cement
 Thread
 Scotch Tape
 Hair wire
 Krylon Spray Enamel—optional

Trace pattern from book onto architect's linen and cut out. Apply rubber cement to can side. Pat pattern onto tin. Cut out. Remove pattern and rub off excess cement.

Fold wings in half, creasing the tin well.

Apply Weldit Cement to inner side of fold and to both sides of small strip on the Bird's back where the wings will rest.

Allow glue to become tacky, then squeeze wings in place, allowing glue to dry with the wings down. (You can cut out another Bird while the first is drying.)

When the glue has dried, test center of gravity of the Bird, with thread and Scotch Tape, sticking them where you think they should go in order to have your Bird "fly right." Make necessary adjustments. Then, with hammer and awl, make hole in proper place. Wire for hanging. (I suggest hair wire because it can easily be bent to compensate for a mistake in judgment.)

Curve wings up to graceful flying position and fringe as indicated in pattern.

Then fringe tail to half-way point, turn over and fringe other half. In this way the Bird's tail will curl *horizontally in both directions.*

Now ornament the Bird with glitter of suitable color, obscuring any lettering which is really distracting. Make a circle with same glitter on his tummy, with dot in center.

Turn over and approximate design on his plain side. Set aside to dry.

He's done and he's delightful. But there is no reason, if it suits your purposes better, why he couldn't be pure white, or red and gold and white, or anything at all that suits your fancy and your color scheme. Spray-paint him, in that case, and add your own unique touches.

Make a mobile! These Bright Birds are meant to fly! (See Color Plate XIII.)

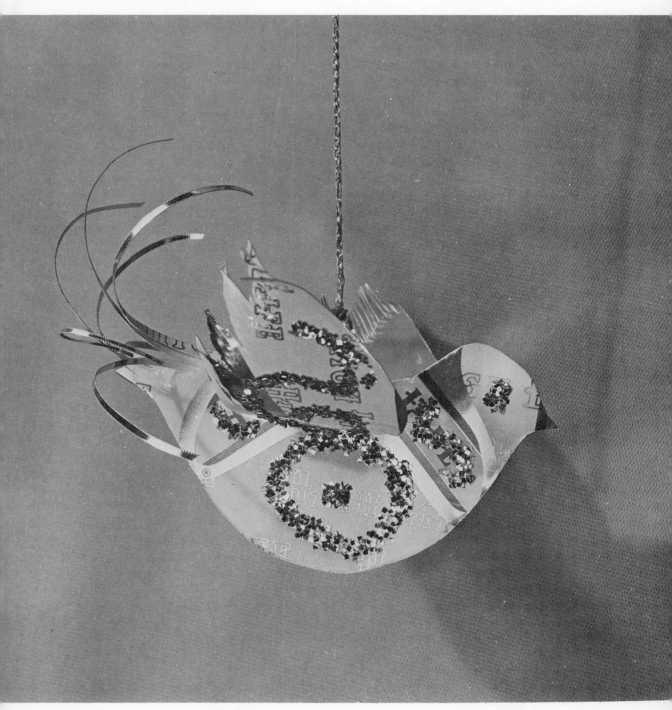

Bright Bird

SNARE DRUM
(Color Plate IX)

Equipment	Materials
Hammer	Small, shallow cans 2½–2⅞ inches
Awl	in diameter
Tape measure	Grease pencil
	Krylon Flat White Spray Enamel
	Masking tape
	Dri-Mark red and blue pens
	Talens glass paint in blue
	Treasure Gold Liquid Leaf
	Gold tinsel cord
	Weldit Cement
	Tiny colored Christmas bells

There is something contagious about a toy drum. Just the sight of it is cheering. And, happily, it couldn't be simpler to make: One only need poke holes in cans—in the right places to be sure! The small 2½-inch minced ham can is a good size for a little tree, and the larger tuna can is right for the tree that reaches from floor to ceiling.

Use the can just as it remains after you have opened it to enjoy its contents. Forget trying to put the top back on; it's too much trouble and the ornament hangs from that side of the can, so it doesn't show anyway.

To mark the places for holes through which you will lace the cord, lay a tape measure around the can's circumference, starting at the seam. You will see that the small can measures just a little over 8 inches. This distance must be divided into four equal parts along the top rim, and into four, *alternating,* equal parts along the lower rim so the cord can zig-zag around the can and come out even at seam.

Therefore, with a grease pencil, mark the top rim at a point 2 inches from the seam (and a smitch more, to use up part of that extra ¼ inch), again at a point 4+ inches from the seam, and still again at 6+ inches from the seam.

Then on the lower rim, mark points at 1+ inch, 3+ inches, and 5+ inches from the seam.

SNARE DRUM
Instruction

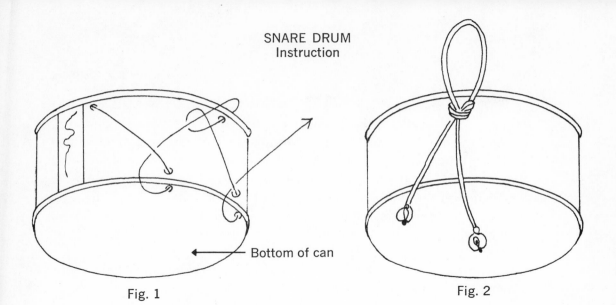

Bottom of can

Fig. 1

Thread gold cord through holes
and pull snug.

Fig. 2

Tie double loop for hanging and sew gay
bells on the knotted tips.

Snare Drum

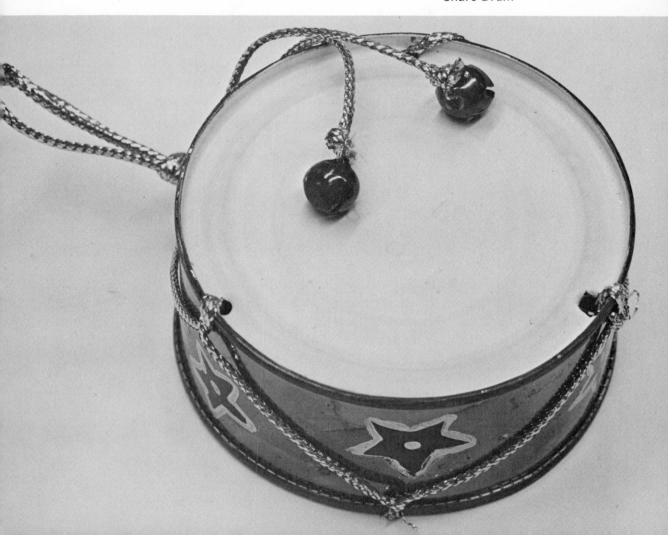

With hammer and awl, *working from the inside,* make holes just under the upper rim at those points you have marked. Make them large enough to allow the cord to pass through without catching. Then make the fourth hole just to the right of the seam under the rim. Since this hole is used both at the beginning and the end of the lacing, it must be large enough to allow two thicknesses of cord to pass through it.

Now make the holes along the lower rim, just *above* the points you have marked. Do this from the outside, with the can on edge and the under part of the can toward you.

Then turn the can bottom side up and make corresponding holes right under those you have just made on the side.

Turn the can over again and, from the inside, waggle the awl around in the holes to flatten the rough edges a bit: These can fray the cord when you lace it through later. However, since the *bottom* of the can becomes the *top* of the Drum, it looks better to have the holes in it made from the outside. (With the other holes you have made on the sides, it doesn't matter, because the cord will cover it.)

Spray-paint the bottoms of the cans with Krylon Flat White Enamel after masking the sides and rims either with regular masking tape, or with a sheet of paper cut in strips to fit and applied with rubber cement.

When dry, remove the masking tape, and paint the sides a lively red and the rims a lustrous blue. Dri-Mark oil-based pens are excellent for this, especially when you are in a hurry, because you don't have to wait for them to dry. But Talens Glass Paints are also transparent and more permanent. You will have to use Talens in any case for the star ornamentation because Dri-Mark will not set-up over itself.

Before you ornament the Drum, however, lace it with cord. Pull out a sufficient length of cord to zig-zag around the circumference of the can and with enough extra to make a loop for hanging and long ends for bells.

Dip the tip of the cord in glue to prevent fraying. Let it dry hard. Then, from the inside, pass the length of cord through the large-ish hole by the seam. Cross diagonally down to the first hole by the lower rim, and poke the cord through to the inside. Then carefully poke it on through the corresponding hole in the bottom of the can. Catch it around the cord on the outside as you pass diagonally up toward the hole on the top (Fig. 1). Carry the cord right over the rim and pass it through the hole from the inside. Catch it around the cord on the outside and bring it diagonally down to the next hole along the lower rim. Repeat the process all the way around to the seam.

Flipping Fish

With the remaining length of cord, make a double loop for hanging and sew tiny Christmas bells onto the knotted tips to suggest drumsticks (Fig. 2).

Now paint the stars on, using the Talens blue first, and then rimming the stars with Treasure Gold. And should you decide to do up a package for a small boy with the Drum on it, use the same gold tinsel cord for tying and sew more gaily colored Christmas bells on each knotted tip of the bow.

FLIPPING FISH

In a beautifully illustrated book by Erwin O. Christensen, *Index of American Design,* you can find the inspiration for my Flipping Fish. It is a nineteenth-century metal weathervane from Rhode Island, perfectly proportioned and molded. Even to approximate him, let alone reproduce him, one would need both chasing tools and a soldering gun which we are not using in this introductory book. But we can capture some of his charm by beating him in a wooden chopping bowl, and if you start at his nose and beat him to the tip of his tail, he'll flip!

Equipment
 Finely serrated snips
 Ball-pein hammer
 Dapping block or chopping bowl
 Awl

Materials
 Sides of can, preferably bright silver and gold
 Architect's linen, pencil, and scissors
 Rubber cement

Rhinestones or glitter for eyes
Glue for glitter
Weldit Cement
Gold cord or hair wire
Dri-Mark pens in lime and pink
Scotch tape and thread

Trace design from book onto the dull side of a piece of architect's linen. Cut out pattern and glue to side of can with rubber cement. Snip out. Remove pattern; rub off excess cement carefully.

Hammer flat and improve the outline.

Fringe tail and fins, as indicated.

Place the tip of the nose in the very bottom of the chopping bowl. Beat tiny hammer marks back and forth from head to tail. He will automatically curl up. When finished, give him a little diagonal twist so he looks like a salmon leaping the rapids.

Spread the fringe of his fins and tail for a little extra flourish.

Fringe two eyes and glue in place. See Idling Fish for directions for hanging.

IDLING FISH

I don't decorate the Flipping Fish because his curves and frilly eye are already so ornamental. Instead, I cut another Fish from the same

FLIPPING FISH
IDLING FISH

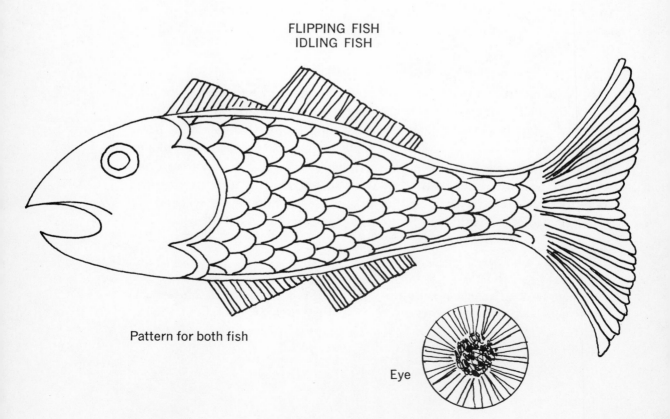

Pattern for both fish

Eye

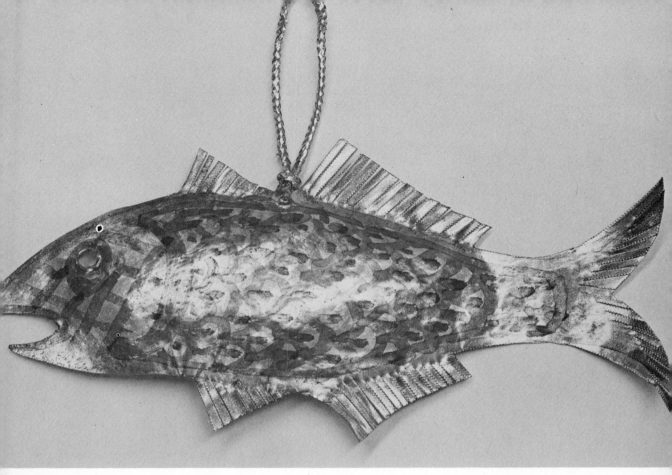

Idling Fish

pattern and beat from his nose to the *end of his fins,* half the length of the body. Then I turn him over, and beat from the tip of his tail *up to his fins.* This makes him curve in two directions at once, which combine to make him go straight ahead! I flatten his nose a bit by pulling on it, and I hammer his fins flat, separating the fringe just a little so they look more flexible. And then I paint him with pink and light green Dri-Mark pens, coloring the fins, tail, and features pink, and filling in the spaces with lime. You have to do this freehand because you can't trace satisfactorily on a curved surface. But it's really elementary if you just remember that fish scales overlap, and that one row of scales rides on the crest of the row before it.

You can jewel his eye, or not, as you wish. But if you do, his head will weigh more than if you didn't and the hole for hanging will, therefore, be proportionately farther forward. Usually you can judge fairly accurately where to put the hole by just picking the Fish up lightly between your thumb and forefinger, but you can make absolutely sure by Scotch-taping a thread where you think it should go and adjusting it accordingly.

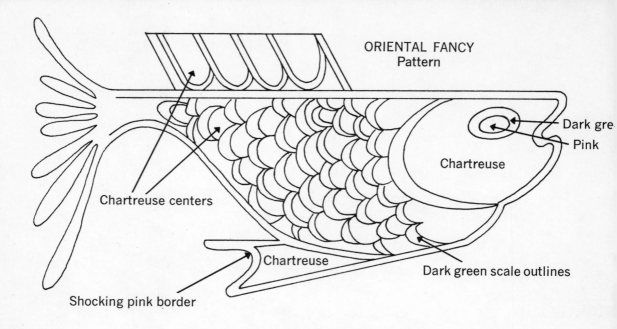

ORIENTAL FANCY
Pattern

Dark gre...
Pink
Chartreuse
Chartreuse centers
Chartreuse
Dark green scale outlines
Shocking pink border

ORIENTAL FANCY

Equipment
Plain-edged snips
Hammer
Awl

Materials
Sides of cans
Krylon Flat White Spray Enamel
or Crystal Clear Spray Lacquer
Architect's linen and pencil
Carbon paper and ball-point pen
Dri-Mark pens in light green, dark
green, and pink
Hair wire, wool, cord, or whatever
Brilliants
Weldit Cement
Scotch tape and thread

Remove lids, rims, and seam of can (see Techniques) and hammer flat. If you want a white Fish ornamented in color, spray-paint the tin with Krylon Flat White Enamel. Otherwise, coat the plain tin with Krylon Crystal Clear so the carbon paper design will show up.

Trace the pattern onto the dull side of a piece of architect's linen and transfer the design to tin with carbon paper. Cut out and paint with Dri-Mark pens. Glue on brilliants for eyes, if you like.

In making the hole for hanging, find the center of gravity with thread and Scotch tape. Then, with hammer and awl, make a hole and suspend the Fish on wire or wool, depending upon how you intend to use it. This fellow looks festive floating under the Dingdong Bell Chime.

ANGEL KITTENS
Pattern

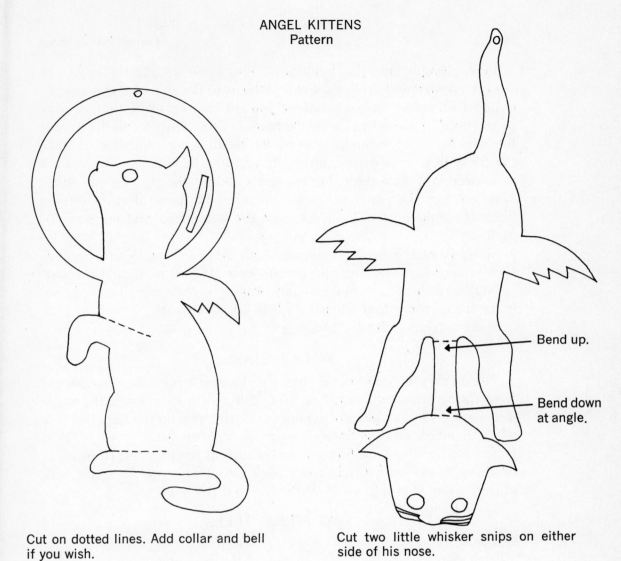

Bend up.

Bend down
at angle.

Cut on dotted lines. Add collar and bell
if you wish.

Cut two little whisker snips on either
side of his nose.

Paint these innocent kittens snow-white and give them sapphire eyes.

ANGEL KITTENS

Equipment
 Finely serrated snips
 Chisel or screwdriver
 Hammer
 Awl

Materials
 Flattened sides of unridged cans
 Architect's linen, pencil, and scissors
 Rubber cement
 Krylon Flat White Spray Enamel
 Colored rhinestones for eyes
 Tinsel cord (optional)
 Tiny Christmas bells
 Weldit Cement
 Hair wire

Trace designs onto the dull side of squares of architect's linen. Cut out each design and apply the linen patterns to the side of a can already coated with rubber cement. Before you cut the tin, make the slit back of the head of the Kitten with the halo. Do this with a chisel (if your husband has one you can snitch without his knowing). Otherwise, make the slit with a screwdriver, hitting it with the hammer as many times as is necessary to make it big enough to admit the tip of your snips. Now cut out the pattern, keeping in mind the general rules offered under Techniques. Once cut, hammer the Kitten flat and improve the outline.

Spray-paint the innocent darling with Krylon Flat White Enamel. Glue on sapphire—or emerald green—eyes. If you wish, add a collar. Either paint one on, or make one of braided wire or metallic cord, and hang one of those tiny Christmas bells at his throat.

Make hole and wire for hanging.

WACKY STARS

These crazy little Stars are fun for the small fry. They are all cut from the same pattern, but hung from different points. Trace the whole page of stars onto a piece of typing paper and glue on the flattened side of a can, or cut out one linen pattern and reposition it.

Spray-paint them a solid color and ornament with Dri-Mark pens . . . or choose a can with Christmas colors and obscure the lettering with glitter . . . or anything at all that's easy and fun.

TWO LITTLE TREES

Equipment
 Finely serrated snips
 Hammer
 Awl

Materials
 Wedges of tin
 Grease pencil
 Krylon Flat White Spray Enamel
 Dri-Mark pens—2 shades of green
 Ruler
 Sequin ornaments and glue

Whenever I accumulate a whole lot of similar, neat little pieces of metal in cutting out an ornament, I always want to make something out of them. These wedges come from the Swedish Star in the heart-shaped space, and, of course, one gets four with every star. I had to make some twelve or more Swedish Stars to hang from a swag across my living room windows and that gave me many too many little wedges to be ignored!

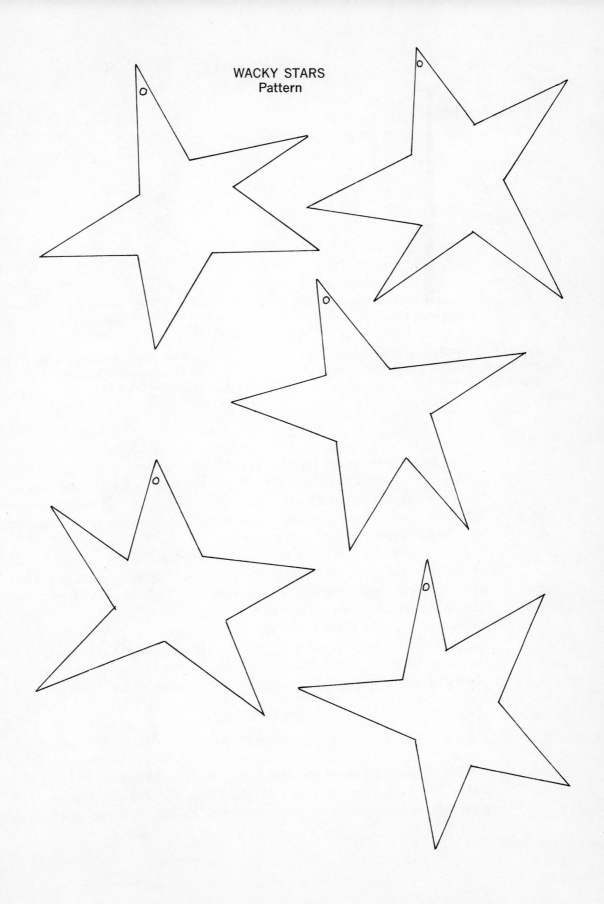

WACKY STARS
Pattern

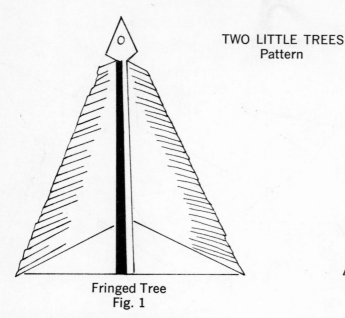

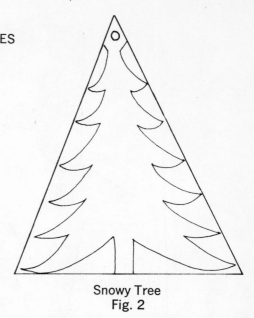

TWO LITTLE TREES
Pattern

Fringed Tree
Fig. 1

Fringe this little tree with serrated snips and define the trunk with two shades of green Dri-Mark pens.

Snowy Tree
Fig. 2

Trace or cut this Snowy Tree freehand and, if you like, trim the branches with gay sequin baubles.

The little Tree on the left I fringed, and the one on the right I cut more realistically. The tin had already been sprayed white, but of course, had to be resprayed lightly after cutting.

FRINGED TREE Make the hole for hanging before you start cutting at all. Then cut the diamond shape around it.

Next, cut the base of the tree (you may want to sketch it in first with grease pencil). Then cut the fringe. Let the tin curl as it wants to. That gives the branches some depth and dimension. Delineate the tree trunk in two shades of green, using ruler to guide the pen.

SNOWY TREE The other little tree on the right I cut freehand, following the same order of procedure, making the hole for hanging first, then the diamond, then the tree trunk, and, finally, the branches. I like it just snowy white, but my children prefer it ornamented with colored sequins.

REINDEER

(Color Plate I)

This charming fellow was sent to me by Helen Van der Pyl, an official of the Girl Scouts, from Oberlin, Ohio. Apparently, she and her girls had made Reindeer by the dozens one Christmas, so perhaps you've

already seen him. The only change that I've made in the original pattern is to lengthen the strips for the legs in order to coil them. Somehow that makes him even prancier, but it also means that you will have to buy a *two*-pound can of coffee this week instead of *one*, because he measures fifteen inches from tip to toe!

Equipment
 Finely serrated snips
 Long-nosed pliers
 Round-nosed pliers
 Awl or pencil to wind legs around
 Gloves

Materials
 2-pound (or even larger) coffee can
 Architect's linen, pencil, and scissors
 Paper clips
 Carbon paper and ball-point pen
 Krylon Crystal Clear Lacquer—
 optional
 Krylon Gloss White Spray Enamel
 Posey Clay

From the flattened side of a 2-pound coffee can, cut a strip ⅞-inch wide and 15 inches long. Much depends upon the exactness and trueness of the strip, so measure and cut it carefully. (If you want more *tightly* coiled legs, cut an even longer strip from an even larger can, but do not change the other body measurements.)

Trace pattern from book onto a long strip of architect's linen, cut to size. With paper clips, attach the linen strip and carbon paper to the tin, and painstakingly transfer all the important features to the tin—such as the jaw line, the ears, the shoulders, and the tail. Spraying the tin with Krylon Crystal Clear Lacquer before tracing helps make the carbon paper lines show up.) Indicate where the long lines for the legs and antlers begin and end, but don't attempt to draw the lines themselves. It's just too complicated, and if you are careful, you will perfectly well be able to cut the strips by eye.

In cutting, you must be *absolutely sure* to make the legs *a full ⅛-inch wide,* if anything, a little *over*. It's better to err that way than to have his legs too skinny. Also be sure to make the antlers a full ¹⁄₁₆-inch wide, if anything, a little over.

Cut on all the lines except those that go across the body. (Obviously you don't want your Reindeer in pieces.)

In shaping your Reindeer, coil the hind legs first. Wrap them around your awl or pencil, starting at the hip bone, and coil them in the *same direction in which the strip is already curving.* (Wear gloves for this procedure.)

Coil the forelegs. Pull on those coils until they attain reasonable leg

length. With the round-nosed pliers, tighten the coils where the hoofs would be.

Now for head and antlers. With *long*-nosed pliers bend the metal on the dotted lines to form the nose of the Reindeer. (On the under side, one fold of the metal will overlap the other.)

With the *round*-nosed pliers, grasp the tips of the antlers and *very loosely* coil them *into themselves* (in the direction in which they are already curving) until they stay curled enough to please you. Pull them out to the side, so he holds them proudly. I give their tips a little extra twist. Suit yourself.

Fringe the neck and tail. Arch his neck and curve his tail.

Round his body a little with the long-nosed pliers. Put a nugget of Posey Clay under his tummy and stick him onto the tip top of your little tree. Isn't he gay?

SANTA CLAUS

Here's a trifle for a small table tree which your children will adore, but which you will have to make because the pieces are so small.

Equipment
 Serrated snips
 Hammer
 Awl

Materials
 Sides of unribbed cans (beer,
 Metrecal, or frozen juice)
 Architect's linen, pencil, and scissors
 Carbon paper and ball-point pen
 Krylon Gloss or Flat White Spray
 Enamel
 Testor's Insignia Red, No. 4
 No. 1 sable brush
 Red thumbtacks for noses
 Sapphire brilliants for eyes
 Clear cement
 Hair wire

Spray flattened side of can (see Techniques) with Krylon Gloss or Flat White Enamel.

While the paint is drying, trace pattern onto the dull side of a piece of architect's linen.

Transfer design to painted tin with carbon paper. Cut out.

With hammer and awl, make hole for hanging in pompom.

Then carefully fringe the beard, pompom, and moustache as indicated in the pattern. Bend up the beard and spread the fringe.

Spray all pieces once more lightly to make snowy white.

REINDEER
Pattern

Fold on dotted line.

Antlers
$\frac{1}{16}$ inch

Cut on all other lines but these.

Foreleg
$\frac{1}{8}$ inch

15 inches

Hind legs

Continue cutting legs
from here to end of
15 inch strip.

SANTA CLAUS
Pattern

Moustache

Eyebrows

Red

Sapphire brilliants for eye

Red thumbtack for nos

Paint cone bright red.

Glue moustache, nose, eyes, and eyebrows in place *in that order*. (Cut the end off the thumbtack, of course.) Wire for hanging.

CANDY CANES

These are real quickies, and children love them. I find that they show up best on a small tree.

Equipment
 Plain or serrated snips
 Round-nosed pliers
 Pencil
 Gloves

Materials
 Red-and-white 1-pound coffee cans

These Candy Canes are made from $3/8$-inch strips, cut from the flattened side of a one-pound coffee can. (You will have to use your judgment about how much writing to include.)

Cut the strips the long way of the can. (The longer the strip, the longer the Candy Cane. So, you can make bigger ones from longer strips and tiny ones from shorter strips, but don't forget to adjust the width of the strip accordingly.)

Wear gloves for the coiling. Wrap the strips around the length of a pencil. Don't attempt to do it well. Remove it.

It will be too fat and shapeless. Twist it clockwise until you form a perfect *tube,* $1/4$ inch in diameter.

Pull the tube out into a spiral until there is an even $1/8$-inch space between the descending curls.

Crook the handle into the Cane (working *with* the spiral, not against it). Fuss with the Cane to get the spirals equidistant, and see if you can't twist the main shaft gradually tighter toward the tip of the Cane.

With round-nosed plier, make a really tight little twist at each end of the Cane to supply a snappy finish.

ICICLES

Here are two icicles, the fringed one for a small table tree, very quick and easy to make; and the curly one for the large formal tree, a little fussier, but oh, so lovely.

FRINGED ICICLE

Equipment Materials
 Finely or coarsely serrated snips Shiny all-silver cans
 Hammer Florist wire (or hair wire)
 Awl

From flattened side of a can see (Techniques), cut as many $3/8 \times 4\frac{1}{2}$-inch strips as you think you want.

Fringe them by making angled cuts in one or both of the ways shown (Fig. 1) starting at the top of the strip so that, as you cut it, the tin is free to curl. When finished, encourage the tin to spiral even further until you get an appealing curve.

With hammer and awl, make the hole for hanging and wire.

CURLY ICICLE

Equipment Materials
 Finely or coarsely serrated snips Shiny cans with *closely* ribbed sides
 (depending upon heaviness of the Hair wire or gold tinsel cord
 tin can)
 Round-nosed pliers
 Long-nosed pliers
 Hammer
 Awl

This lovely design was conceived by Miss Lydia Hunt. When she was making stars with spokes one night, it suddenly occurred to her to use the spokes separately as Icicles. (You see how logically one process suggested the other? This will happen to you, and you'll soon be making designs of your very own.)

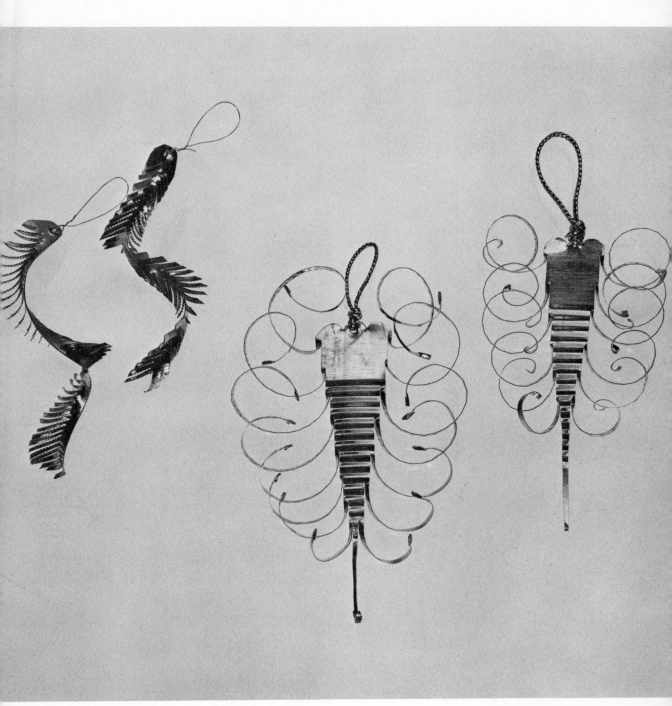

Icicles

ICICLE
Diagram

4½ inches

Fringed Icicle

Fig. 1 Fig. 2

¾ inch ⅞ inch

4 inches

Curly Icicle

Fig. 3
With rim removed

Fig. 4
With rim left on

I have adapted Miss Hunt's idea a little by making a twist on the end of each of the curls, just as I did for the Imperial Star design. If you have already made that star, you will know what I mean. Otherwise, when you get to that point in these instructions, look up the Imperial Star procedural photographs so that you can see exactly how it is made.

There is another way to get very much the same effect which occurred to Mrs. Benjamin Luden. She thought of leaving the rim of the can *on,* instead of removing it, and cut *through* it, so that she then would have a little "zing" built-in to the end of each curl. You can see from the photograph that that nubble gives the ornament real character and articulation. However, since the rim is always hard to cut through, be careful to aim your snips in exactly the right direction—brace the handle against your stomach—and keep the fingers of your helping hand out of the way, either *well above the cut,* or *well under, on the rim itself.*

One more thing: you might think this Icicle would be even prettier if made with silver and gold cans. It is not. The two colors destroy the unity (or form). It's the fine ribs that are important and the shininess of the silvery can.

Remove the lids, at least one rim (see above), and the seam from a shiny, closely ribbed can.

Cut ¾- or 1-inch strips *parallel* to the seam (vertically, in other words, around the side of the can). If you don't trust your eye to make nice straight strips, see Techniques—On Dividing the Sides of Cans into Equal Sections.

Trim the top of the ornament first, as shown, and make hole for hanging with hammer and awl.

Cut curls according to patterns given (Figs. 3 and 4).

With thumb and forefinger, turn all curls out to the side.

With round-nosed pliers grasp each tendril by the tip and, by twisting your wrist toward the center of the Icicle, very *gently and loosely* coil the tendril within itself. If you form kinks inadvertently, straighten them by pinching them with the *long*-nosed pliers. Then curl again.

Once you've gotten all the tendrils to curve like those in the photograph, put a little snick on the tips as described in the Imperial Star design.

Wire for hanging with hair wire or gold tinsel cord.

Fig. 1

DINGDONG BELLS

Bells are synonymous with Christmas, and these simple ones are not only child's play to cut out, but a child's delight to decorate. I am thinking now of rainy days in the Maine woods when cousins "by the dozens" sat around card tables with me and dabbled in oils to their hearts' content, dreaming up designs for these Dingdong Bells. Then we made them into Wind Chimes, as you will see later, and hung them from the center of each window in our open kitchen. Such a cool sound you can't imagine!

Equipment
 Plain or finely serrated snips
 Hammer
 Awl

Materials
 Sides of coffee cans
 Architect's linen, pencil, and scissors
 Rubber cement
 Krylon Gloss White Spray Enamel
 Dri-Mark nylon-tipped pens in gay colors or quick-drying model paints
 Wire or bright green wool

Trace pattern from book onto dull side of square of architect's linen and cut out.

Apply with rubber cement to flattened side of coffee can and cut out.

Use the metal Bell as a pattern with which to make a frieze across the can (Fig. 1) using an awl to scratch the outline.

Cut out all the Bells. Make holes with hammer and awl, and use wire or wool for hanging. Paint on whatever designs you wish.

DING DONG BELL
Designs

Alternating dark green and light green on white

Shocking pink bands with alternating pink and light green scales

Dark green band

Light green blobs and palm leaves with dark green blobs inside

Light green criss-cross with dark green blobs and bands

GARLAND
(Color Plate I)

Every tree should have a garland, don't you think? If you will look at the picture of Little Christmas Tree, you will see the Garland that the children and I made in part of two afternoons. Even though there are at least one hundred stars in it, and though it measures twenty-one feet long, it only goes (generously) around that little tree. Next year we will double it. And we agreed that beautiful though it is in alternating shades of red, green, gold, and silver, *on the tree* it would be more effective if it were popcorn-white. Festooned against the wall or along the cornice, it shows up beautifully in color, but on the tree, even though it sparkles, it blends. So you might keep that in mind when you decide to make one.

The children figured out real assembly-line techniques to facilitate what might have seemed an endless process, making all the snips in the tips of the stars first in one direction, then the other (see the Sparkler diagram). This way they avoided turning their heads and hands on each section. They worked out an equally efficient system for coloring in two shades of red and green Dri-Mark pens, and in lining up the stars in alternating colors for me to pick up and knot on thirty feet of red tinsel cord. We threaded ours through holes in the center and knotted them on either side every two inches along the cord, but there again we agreed that they might have been more effective hanging from the cord by one tip so they could be viewed head-on. All the same, we think it worth making for it can't shrivel like cranberries. We will enjoy it for years!

PART THREE

TREASURES FOR THE HOUSE

WREATHS AND WIND CHIMES

A wreath is the universal symbol of good will and welcome, and just as you will find a tree in the heart of most homes at Christmas time, you will find a wreath on the door. For, more eloquently than words, a wreath proclaims the presence of the Christmas spirit in each house and extends a warm and friendly greeting from everyone in it to all those who pass by, friends and strangers alike. And a wind chime, swinging from the inside of one's wreathed door, will prolong that welcome and augment that greeting with the silvery sound of bells.

Bells can be made just as easily from tin as the stars to stud your wreath. Here you will find ways and means to make and use them both.

STAGHORN WREATH

(Color Plate IV)

This wreath is distinguished, partly because of the rich gold bow and the white enameled stars on it, but also because of the fullness of the White Pine wreath itself. I make it the old-fashioned way, with strips of sheeting wrapped around a metal frame, stuffing each fold with thick clusters of needles on both sides. The wreath measures a generous twenty-four inches across and smells positively scrumptious.

Equipment
Finely serrated snips
Hammer
Awl

Materials
Wreath frame
5 lids from 2-pound coffee cans
5 2¾-inch lids with gold linings

123

Krylon Gloss White Spray Enamel
Weldit Cement
5 Decora upholsterer's tacks
2 yards of olive-green velvet ribbon
 (2¾ inches wide) with picoted,
 wired edge
2 yards of gold metallic ribbon
 (1¾ inches wide)
Florist wire

Make five Staghorn Circles from the 2-pound coffee can lids, by dividing each lid into 16 equal sections and ornamenting the tips with U's. (See photograph of Staghorn Circle with Fringed Whorl, page 56.) Spray-paint with Krylon Gloss White Enamel.

At the same time spray-paint the five 2¾-inch lids on the *silver* side. When thoroughly dry, make Fringed Whorls according to directions for same, alternating the design in the tips with Staghorn and Fringed.

Place Whorl inside of Staghorn Circle and make hole, with hammer and awl, through the center of both. Apply Weldit Cement to hole both front and back and push a Decora upholsterer's tack through.

When dry, clip point off tack and wire the star with a 6-inch length of florist wire, drawn invisibly *between* the sections of the Staghorn Circle, *under* the Whorl.

Repeat with all five stars.

Make bow of gold metallic ribbon placed on top of velvet and wire to Wreath at center top.

Center one star at bottom of Wreath directly under bow. Space others evenly to right and to left and wire in place.

FRINGED WREATH

(Color Plate VII)

In contrast to the restrained opulence of the Staghorn Wreath, the Fringed Wreath radiates a certain robust informality. Unpainted, it is obviously made of tin, and mounted on a thick native Juniper wreath and hung on the barn door, it proclaims the festive season in engagingly primitive terms.

It is equally suitable indoors against the old brick of a country kitchen, where it fraternizes quite naturally with the polished pots and

pans. And someday I should like to see it, by itself without the wreath, hung against the black hood of a contemporary fire pit.

Equipment	Materials
Coarsely serrated snips	Sides from 2 2-pound coffee cans
Hammer	Lid from 1 1-pound coffee can
Awl	Side of 1 1-pound coffee can
	Weldit Cement
	Decora upholsterer's tack
	Florist wire

Cut the flattened side of one of the 2-pound coffee cans into four equal strips (approximately 1⅝ inches wide and 15 inches long) by cutting down the center of each rib. This provides a nice, beveled edge.

With these strips make a Staghorn Star with 2-inch deep U's (see basic Scandinavian Star instructions).

Cut the flattened side of the other 2-pound coffee can in the same way, making the strips 11 inches long. From these make a Fringed Star according to the basic Scandinavian Star instructions.

From the side of the 1-pound coffee can make a 5¾-inch Fringed Star in the same fashion.

And from the 2-pound coffee can lid make a Fringed Whorl with twenty-four sections only, rather than thirty-two. (Needs to be bold.)

With hammer and awl, put a hole in the center of each star.

Layer the stars one above the other in such a way as to alternate the spokes, putting drops of Weldit Cement in the holes between each layer.

Push Decora tack through all holes and let set overnight before wiring (invisibly) across the middle.

WIND CHIMES

To judge from the number and variety one sees, everyone must love wind chimes. And certainly it is pleasant to hear them tinkling coolly in the shadows as a vagrant summer breeze stirs them. But when winter comes and we stay snug inside, we seldom hear their sweet sounds, and I feel that one of the happiest inspirations I have ever had was to bring the wind chime in from the arbor and hang it from a scroll in the center of our front door where it sings melodious madrigals every time we come and go—in a sort of continuing celebration of existence, as it were, and a positive caroling at Christmas!

I have made four for you: two that children can make in a twinkling and two that require a little more patience and skill.

DINGDONG BELL CHIME

Perhaps you have already come across the Dingdong Bells under Trifles for Tree. To make a chime, simply suspend them from the rim of a can with short strands of wool. You can improvise any way you like with these. As perhaps you can tell from the photograph, I spray-paint the Bells and the Medaglio d'Oro coffee-can rim with Krylon Gloss White Enamel; then paint them in gay colors with nylon-tipped Dri-Mark pens. Their sound is cool as well water.

I discovered the charm of simple metal cones one summer when the children and I happened on a Penobscot Indian festival in Old Town, Maine. We had gone there in search of moccasins, and crossing over the bridge to the island reservation in the river, we found the Indians gathered together in full regalia in front of their church. To solemnize the occasion there were some thirty priests, garbed in black cassocks and white lace cottas and caps. Every Indian on the island, including the smallest black-eyed baby, was arrayed in a festive costume of deerskin ornamented with feathers, beads, and metal bells. We were enchanted by those little bells, hanging in three's from supple leather thongs along the edges of the skirts and jerkins and tinkling sweetly at every motion.

Everyone, it seemed, was waiting for the Bishop. The Chief lead a delegation across the bridge to greet him, and soon they all returned, the Chief nodding his plumed bonnet graciously at the Bishop splendidly arrayed in capacious robes of scarlet and purple. Then, to the tinkling of all those little bells, the Chief and the Bishop led the procession of priests and Indians through the church gate to the river's edge where they were to complete the festival ritual with a dance. Since outsiders were not invited, we wistfully watched them disappear, then went straight home to make Wind Chimes with those little bells.

MADCAP WIND CHIME

The Bells in this Wind Chime look like little elves' caps and are so easy to shape with your fingers that you can assemble the whole thing in a matter of minutes. So can your children!

The Chime requires no special tools and you will only have to go out and buy a small hank of orlon sock yarn—*orlon,* because it won't shrink in the rain, and *sock* yarn, because it is the right weight for the size of these particular Bells.

As to string, you could use it, in a pinch, but there is something

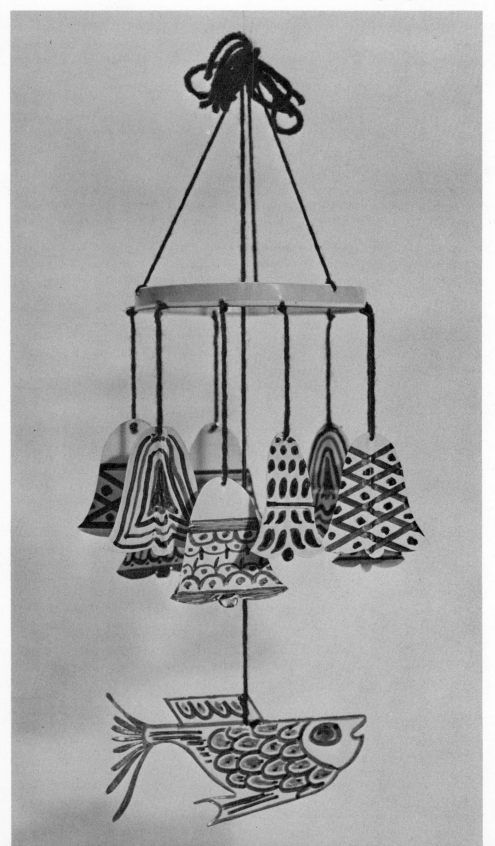

wrong with most types. The brown twines are too wiry, and the soft cottons are usually white and don't blend with natural materials. The balls of fuzzy string that come in green or rust-red would "do," but yarn is in every way more satisfactory—in color, texture, appearance, and availability.

Always keep in mind, in buying any yarn or string for a Wind Chime, that it *must be limp enough* to let the bells hang down straight; that it *must be an appropriate weight* for the size of the Bells; and that it *should harmonize* with nature. There is nothing more garish than an artificial green placed next to the olive-green of nature. They both come off badly. Instead of looking bright and gay, the artificial green looks cheap and the real "live" green looks dead. So, if you like the idea of wreathing the top tier of the Chime with yew or bits of holly, take a snippet along with you and match the sock yarn to it. You can then get the effect just right. Otherwise, any good dark green will do nicely with the gold and silver Bells.

Equipment
 Any ordinary scissors
 Hammer

Materials
 Small hank orlon sock yarn
 Large can rim (about 4 inches)
 Small can rim (about 2 inches)
 9 lids from small frozen juice cans, gold lined
 1 larger lid, gold lined
 Crayon
 Clear cement
 Lightweight wire

Cut nine 9-inch lengths of yarn to hold the bells. Knot each end.

Cut three 7-inch lengths of yarn. Tie these onto the large rim at three equal intervals. Clip off tag ends. Daub the knots with cement.

Cut three 8½-inch lengths of yarn. Tie onto the smaller rim at three equal intervals. Clip off tag ends. Daub with cement. Set both rims aside to dry.

Hammer all the small can lids flat: six on the silver side for use gold side out, three on the gold side for use silver side out. Hammer the larger lid on the silver side for use gold side out. (This will make twelve gold Bells for the top tier, six silver Bells for the lower tier, and one larger gold bell for the center.)

Snip off any rough edges and cut lids in half. Mark the center of the straight edge with a crayon (Fig. 1).

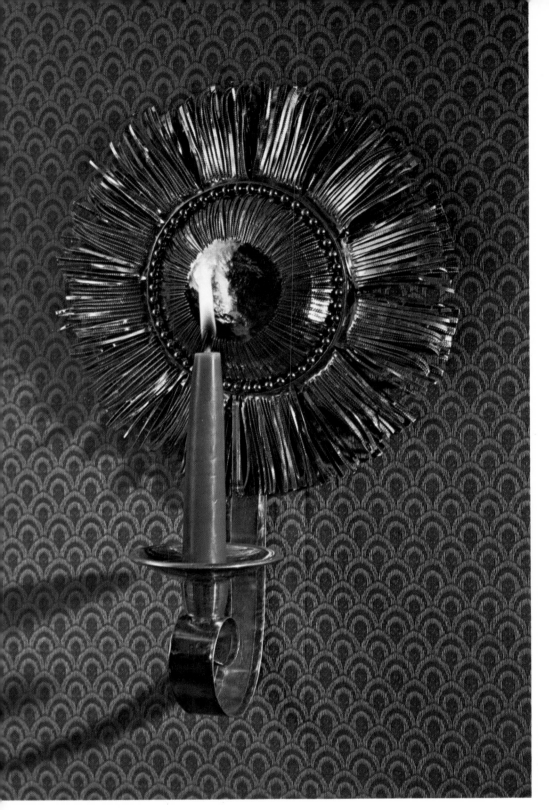

VIII—Sunflower Sconce

IX—*Above, gifts trimmed with Seal, Apple, Jumping Jack, Idling Fish, Mexican Sun, and Snare Drum X—Below, gifts trimmed with bookmarks*

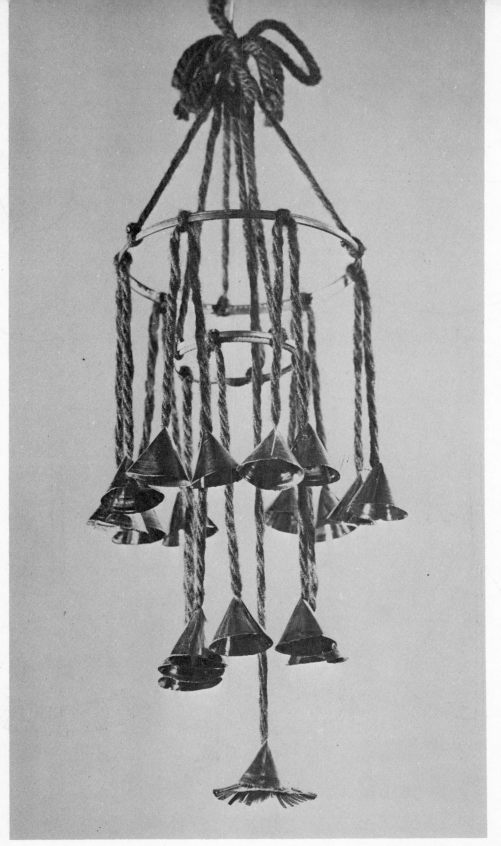

Madcap Wind Chime

MADCAP WIND CHIME
Diagram

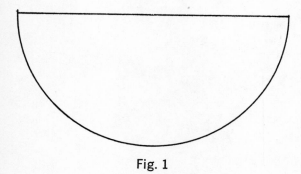

Fig. 1

Fig. 2

Fig. 3

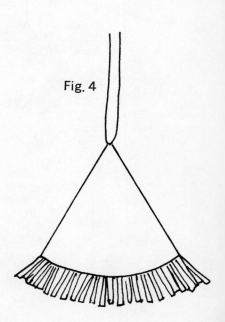

Fig. 4

Holding the piece of tin in both hands, curve it into an inverted U by rubbing it with your thumbs down over your fingers (Fig. 2) so that it forms what might be a saddle for a very small animal.

Pinch the straight edge at the center mark with your thumbs to make the pointed top of the cone. Bring the two straight edges together, overlapping them a bit.

They will spring back a little and leave you room to insert one knotted end of yarn inside the top of the cone and squeeze the Bell shut (Fig. 3).

Repeat until you have twelve gold Bells and six silver Bells on opposite ends of the strands of yarn. (It goes without saying that the more Bells, the merrier the sound, so don't hesitate to fill out the rims with as many bells as you are inspired to make.)

Make the center Bell the same way, inserting a 14-inch length of yarn knotted at one end. Fringe the Bell, if you like, by making $\frac{1}{16}$-inch cuts along the edge (Fig. 4).

Hang the gold Bells over the larger rim, placing two in each interval between the strands of yarn which will hold the tier. Suspend each pair of Bells evenly. Tie in place with just one knot. (This makes them easy to adjust and you can tie a second knot later when you are sure you have everything right.)

Hang the silver Bells from the smaller rim and knot in place. Assemble the Chime by drawing the tip of the strand on the center Bell up through the strands of the lower tier and those together in turn, up through the strands of the upper tier. Bind all the strands together with wire, about an inch and a half down from the tips, and make a loop for hanging.

Level the tiers by holding the Chime at the "neck" and pulling *down* on the rims where they are too *high*. That works better than pulling *up* on the proper strand—even if you could find it!

Tie two cheerful bows of yarn, with fat loops and short ends, over the wire binding, front and back. Hang the Chime outdoors, on the branch of a tree or in the breezeway. As poet John Ciardi might say: "A wind chime is to hear!"

Which brings up the subject of tone. Generally speaking, the narrower the bell, the clearer the tone; and the heavier the metal, the brighter the tone. Also, the smaller the bell, the higher the tone; and the larger the bell, the lower the tone. That is the reason the Penobscot Indians used *little, narrow* bells on their costumes: they wanted *light, bright* tinkles of sound. So I will now give you directions for a truly Indian Wind Chime.

PENOBSCOT INDIAN WIND CHIME

It would be wonderful if books could have sound tracks built into them so that you could hear the luxuriant tintinabulation this chime sets up. You would just love it. And it would cheer you on as you work your way through the myriad mechanics. Don't be discouraged. Remember that if you hang it on the inside of your front door, it will give you constant pleasure.

Equipment
 Plain-edged snips
 Hammer
 Awl
 Round-nosed pliers
 Long-nosed pliers
 Ruler and grease pencil (if necessary)

Materials
 1 6-inch diameter (3 pound fruit) can and lid
 2 5-inch (2-pound coffee can) lids
 2 4-inch (1-pound coffee can) lids
 1 12-ounce coffee can rim (Medaglio d'Oro)
 Hank of dark green rug yarn
 Florist wire

Start with the Tiers

You will notice that the tiers in this Chime are not made from narrow rims, but from wider strips of tin. They provide a richer appearance to go with the richer sound.

For the top tier, I like to use a ready-made band which runs *around the top of the lower section* of a Medaglio d'Oro coffee can. This can be removed intact by yanking it off with long-nosed pliers *at the point where it is stapled together* (that is, stapled *to itself,* not to the rest of the can). This will save you the bother of making one from the side of a can.

If you are lucky enough to have one, stand it up on its side (Fig. 1) and, with awl and hammer, make three equidistant holes near the upper edge of the rim for the strands of yarn to hold the Chime.

If you do not have such a rim, you will have to make all three tiers for this Wind Chime. To do that, cut three grooved strips, ½-inch wide, from the side of the three-pound fruit can. Use the full length (16 inches) for the largest tier; a 12-inch length for the middle tier; and a 6½-inch length for the lowest tier. Hammer them flat to make them more pliable and less apt to crease.

In order to form them into hoops, make *two holes in one end of each strip* with awl and hammer. Coil the hoops and mark the spots for two corresponding holes in the other ends. With hammer and awl, make the holes.

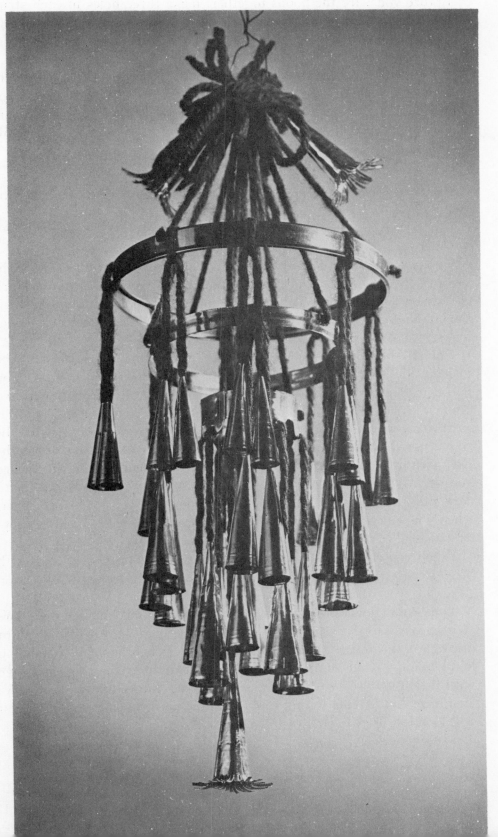

Before you wire the hoops together, make three holes in each strip, equal distances apart, for the strands from which the tiers are to hang.

Now wire the hoops together with three ½-inch pieces bent into U's. Pinch tight.

To suspend the tiers, cut three 7-inch strands of yarn for the top tier; three 8-inch strands for the second tier; and three 9-inch strands for the third. Knot one end of each strand. Working from the inside, pull the strands through the holes in their respective rims. Set aside while you make the Bells.

Fashion the Bells

First cut eighteen 9-inch strands of yarn from which to hang the Bells. Knot *each* end.

Cut a 15-inch strand for the low center bell. Knot *one* end.

Cut two 3-inch strands for the bow Bells. Knot *one* end.

To make the Bells themselves, divide the 6-inch diameter lid into eight sections by cutting it in half, then in quarters, then in eighths. (Mark the center with a grease pencil, if you want to, and with a ruler, draw the line that divides the lid in half. After that, cut each piece into halves by eye.)

Cut off the points, as shown in Fig. 2. Hammer the pieces on the inside. You will notice that hammering curves them up a little. You will continue that curve when you bend the tin with the round-nosed pliers.

Starting at the outer edge from the bottom, grasp the tin with the round-nosed pliers, palm toward you. Work across the inside of the Bell with little inward twists of the wrist, thus bending the tin toward you slightly (Fig. 3). *Move no farther than the width of the plier with each twist.* This way you make a continuous curve. Therefore, later, when you squeeze the Bell with your fingers, the metal will curve properly instead of creasing.

When you can go no farther one way, turn the piece over and, with little twists *away* from you, work the tin in the opposite direction (Fig. 4).

Then come down from the top on the inside and, holding the pliers at an angle (Fig. 5), coax the out-of-shape edge into a nice straight line again, with little *in*ward twists of the wrist, bracing your holding hand against your stomach. Similarly, straighten the opposite edge with little *out*ward twists of the wrist. Don't hurry and don't worry! Just have fun fussing with it and teasing it until it comes true! Then it will look like Fig. 6.

PENOBSCOT INDIAN WIND CHIME
Diagram

Fig. 1
Make 3 equidistant holes in rim.

Fig. 2
Cut off point.

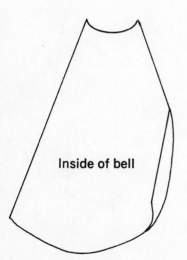

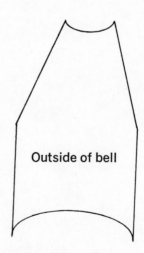

Inside of bell

Outside of bell

Fig. 3
Bend the tin toward you.

Fig. 4
Turn over, work tin in opposite direction.

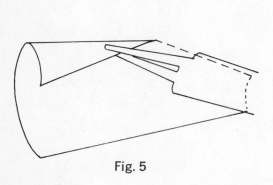

Fig. 5

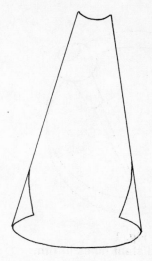

Fig. 6

Fig. 7

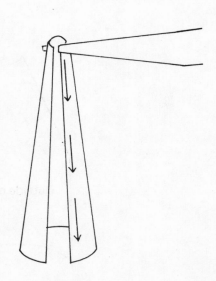

Fig. 8

Fig. 9

Now grasp the Bell firmly with the pliers from the top, and carefully pinch the lower section part way together with your fingers.

Then withdraw the pliers until only the tips are holding the Bell, and pinch the *top* section of the Bell part way together again with your fingers (Fig. 7).

Switch to the long-nosed pliers. Working down from the top, squeeze the Bell with the pliers just enough to flatten the right-hand edge of the Bell so that it can pass under the left-hand edge (Fig. 8).

Before you squeeze the Bell completely shut, insert one of the knotted strands of yarn. Then, holding the flattened edge with the pliers (Fig. 9), squeeze the Bell together with the fingers of your helping hand, overlapping the seam a bit. Flatten the overlap by squeezing it from top to bottom with the pliers.

Finally, pinch the seam flat by inserting the pliers into the Bell from below and squeezing the overlap.

(All this time you have been pinching and pushing with your helping hand—not to mention your stomach!—shaping the metal into a cone. Soon you will learn how each plier works and what it can do for you: Basically, the round-nosed pliers curve the tin and the long-nosed flatten it. If the Bell is not perfectly cylindrical, you can straighten the "bends" with the long-nosed pliers, always going back in the end to tighten the seam which may have opened up.)

Altogether, for this Chime, you will need sixteen small Bells (made from the two 4-inch lids); sixteen medium-sized Bells (made from the 5-inch lids); and eight large Bells (made from the 6-inch lid). That may seem like a lot of bells, but together they sound like a choir of angels and will give you everlasting pleasure. Once you get the hang of making them, you'll be surprised to see how fast they accumulate. Don't forget to insert the knotted strands as you go along. It's much easier than poking them through the top later.

Attach one big Bell to the 15-inch strand and two big Bells to the short 3-inch bow strand. Fringe these Bells half an inch deep.

Assemble the Chime

Hang the strands with the sixteen *smallest* Bells over the top tier and knot them evenly in place.

Hang six strands with twelve medium-sized Bells over the second tier and knot them in place.

Finally, hang two strands of medium-sized Bells and two strands of large Bells on the lowest tier, alternating the sizes, and knot them in place.

When it comes to putting the three tiers together, you will wish you had twice as many arms, but persevere! Pick up the low center Bell and draw it through the lowest tier, which you are holding by the tips of its strands. Then pick up the tips of the middle tier and pull those of the lowest tier up through, and so on. When you get everything pulled through, more or less, lay the Chime down carefully, and gather all the strand tips together.

With a 6-inch length of florist wire, bind the strands together 1½ inches down from the top. Fashion a loop for hanging while you're at it.

Now hang the Chime on a hook (kitchen towel rack is good) and make the necessary adjustments, leveling the tiers by pulling *down* on the rims where they are too high, holding onto the "neck" firmly as you do it.

Trim with a Bow

Cut two 14-inch strands of yarn and fold them as in Fig. 10. Place them front and back of the wire binding. Catch in the two fringed Bells. Tie all firmly in place with a 6-inch strand of yarn.

Isn't it charming? And doesn't it make a delightful sound?

Fig. 10
Shape yarn into bow.

TRUMPETING ANGEL WIND CHIME
(Color Plate II)

The Penobscot Indian Wind Chime was designed to hang out of doors under the grape arbor and accompany the murmurings of the mourning doves who nest there, but the Angel Chime was intended to swing only in a white and gold paradise. One of my fondest and most fastidious friends dwells in just such a heavenly habitation and I designed this expressly for her.

Equipment
 Plain or finely serrated snips
 Round-nosed pliers
 Long-nosed pliers

Materials
 1 Trumpeting Angel
 1 can 4¼ inches in diameter
 1 rim 3 inches in diameter
 1 rim 2 inches in diameter
 12 small frozen juice lids, bright gold
 1 ounce fine, lustrous, white wool
 Krylon Gloss White Spray Enamel
 Clear cement
 Hair wire
 Gold and silver Decorette ribbon

Make the Tiers

Remove both ends and one rim from the 4¼-inch can. Cut the sides of the can down to within ⅜ of an inch of the bottom rim. Fringe to rim. (If in doubt, see Techniques, On Fringing Tin.)

Ornament the other two rims. (See Techniques, On Ornamenting Rims.)

Spray-paint all three rims with Krylon Gloss White Enamel.

Fashion the Bells

First cut forty-eight strands of wool 2¾ inches long. Knot both ends of each. Set aside for Bells.

Cut the Bell wedges from the twelve frozen juice lids by dividing each lid into *four* sections.

Clip the top points off each wedge, and with round-nosed and long-nosed pliers, form forty-eight Bells according to the directions given in the Penobscot Indian Wind Chime.

(Don't forget to slip the knotted end of the wool strands inside the Bells to hang them by before you close them completely.)

Assemble the Chime

First put the tiers together: Cut three 4½-inch wool strands for the top tier; three 5½-inch strands for the middle tier; and three 6½-inch strands for the lowest tier.

Knot *one* end of each strand.

Catch the knotted ends of the 4½-inch strands into the fringe on the top tier at three equidistant points on its perimeter.

Catch the knotted ends of the 5½-inch and 6½-inch strands into the ornamentation of their respective rims at three points equidistant on their perimeters.

Secure all fastenings with tiny drops of clear cement.

Suspend the Trumpeting Angel from a wool strand 12¾ inches long. Pass the tip of her strand up through those of the lowest tier. Holding *them* together, pass their tips up through those of the middle tier. Pass those, in turn, up through the strands of the top tier and bind all together with hair wire about 1 inch down from the top.

Tie an airy, bouffant bow of gold and silver Decorette ribbon at the "neck" and suspend the tiers from a handy hook (kitchen towel rack, etc.).

Slipping the knotted ends of the Bells through the fringe and rim ornamentation, hang twenty-four Bells from the top tier, fourteen Bells from the middle tier, and ten from the lowest tier, spacing them evenly. Secure with touch of clear cement.

If these Chimes are to herald your family's comings and goings, attach them to the top of your front door with a scroll. You will find instructions for making the Scroll under Techniques. When finished, make two holes in it: one at the straight end to hold the Chime on the top of the door and one at the outermost curve of the Scroll itself to suspend the Chime (Fig. 1). Squeeze loop on Chime tight enough to pass through hole in Scroll and bend over tight enough to hold in place. Tack wind Chime to center top of door. (Incidentally, should you wish to place the Chime on a bedroom door, rather than on the front door, be sure to have it face the *in*side of the room. Otherwise you will find the outside casing of the door bending the Scroll down.)

TRUMPETING ANGEL WIND CHIME SCROLL

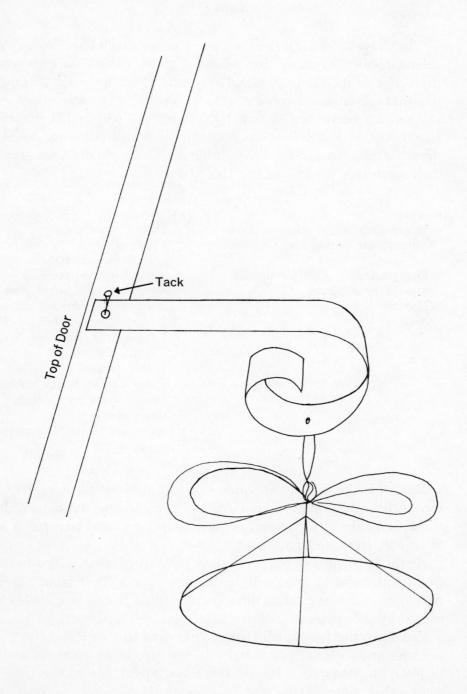

ADVENT WREATH
(Color Plate VI)

The Advent Wreath delights me quite as much as a Swiss Advent calendar, with its many tiny windows to be opened, delights my children. For in its quiet, candle-lit way, the Wreath declares to me each day that Christmas is coming. It casts a peaceful presence over what is otherwise a hectic period, and I think you too will find it surprisingly sustaining. If you follow the tradition, you will put it up on St. Andrew's Day, November 30, lighting first one candle then one more each successive week until the Eve arrives.

Equipment
 Heavy-duty snips (if you have them) for cutting the hardware cloth
 Finely serrated snips for the Imperial Star cluster
 Hammer
 Awl

Materials
 Balsam wreath
 Circle of ¼- to ½-inch hardware cloth to fit wreath
 4 small frozen-juice cans
 4 votive candles in red glass jars
 2 1-pound coffee cans and 1 lid
 Krylon Metal Primer Spray Enamel
 Krylon Gold, Brass, or Tangerine Spray Enamel
 Weldit Cement
 Posey Clay or Vogue Stikum
 Decora upholsterer's tack
 Green florist wire
 4 yards of 1½-inch bittersweet velvet ribbon

Buy, or make, a thick Balsam wreath. It need not be more than fourteen inches wide, unless your front hall is enormous, but inasmuch as it is the first sign of Christmas in your house, it should be *a full 5 inches* thick and fresh and fragrant!

At the hardware store, purchase a piece of grating, called hardware cloth, with holes ¼ to ½ inch in diameter. Cut a circle from it 3 inches narrower in diameter than the wreath, so that it will be completely obscured by the sprigs of Balsam as it rests on the wreath.

Cut down the four small frozen-juice cans to 1 inch in height. With hammer and awl, make two holes in the bottom of each can and wire in place on the circle. (If you think you might like to use the frame some other time during the year—with Oasis—for a fresh flower

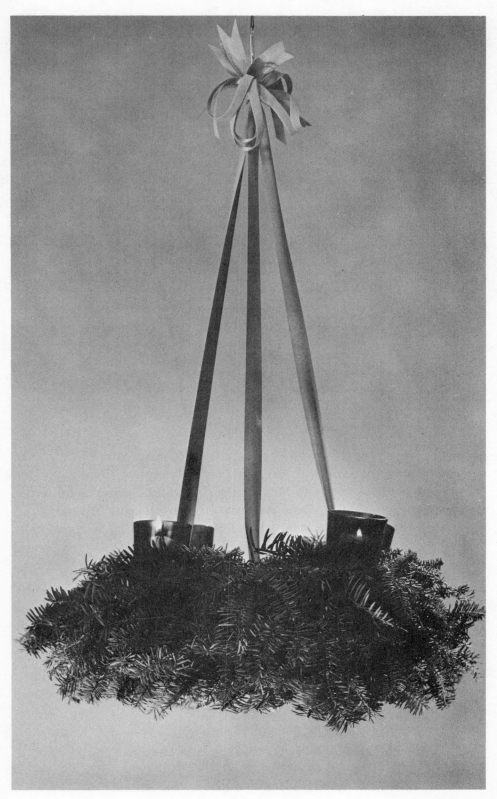

Advent Wreath

Advent Wreath procedure

wreath on the dining table, waterproof the holes in the cans with Weldit Cement.) Spray-paint it with Krylon Metal Primer.

Cut four 6-inch lengths of florist wire. Form them into hairpins and wire the hardware cloth circle in place on the wreath. Pull sprigs of Balsam up through and around the circle, camouflaging it completely.

Make a beautiful Imperial Star cluster to ornament the underside of your Wreath. My cluster has four layers. The largest star measures 10 inches in diameter with strips $1\frac{3}{8}$ inches wide. The next largest measures 8 inches, with strips 1 inch wide. The third star measures 6 inches and was also made of 1-inch strips. The center is an elaborate, Fringed Whorl made from the lid. Once made, spray-paint them all with Krylon gold, brass, or tangerine.

With hammer and awl, make a hole in the center of each star. Position the stars one above the other with Posey Clay or Vogue Stikum so that the spokes alternate and form a fairy cobweb. Pour Weldit Cement inside the Decora upholsterer's tack and down the center hole in the stars. Stick it all together, push a little ball of Posey Clay over the point of the tack on the back side and let dry.

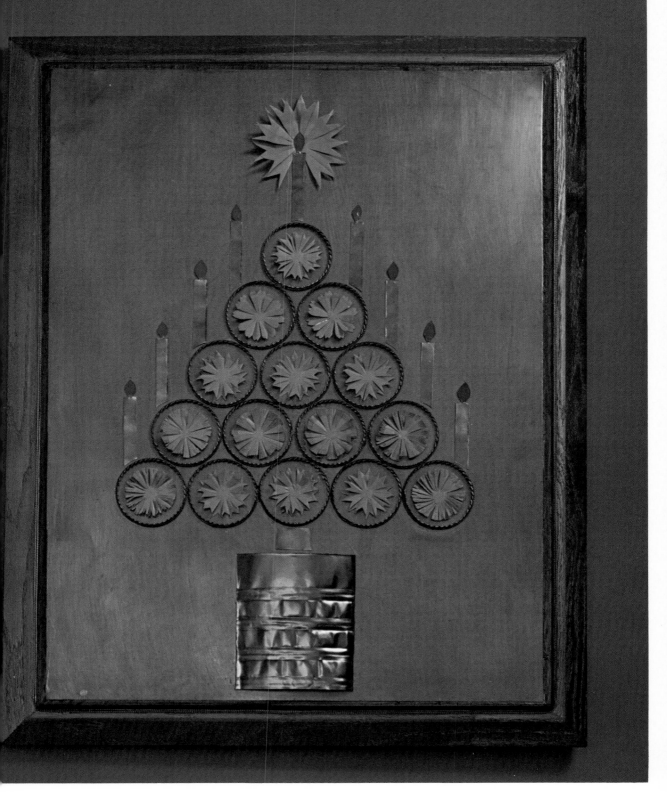

XI—Snowflake Tree

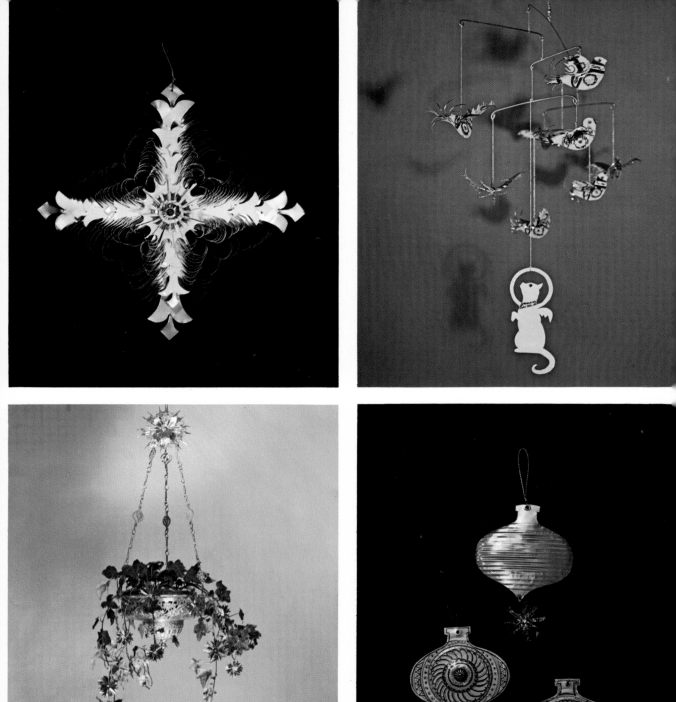

*XII—Top left, Swedish Star XIII—Top right, Bird Mobile XIV—Bottom left,
Hanging Basket XV—Bottom right, Christmas Onions*

In the meantime, cut the bittersweet velvet ribbon into four 1-yard pieces. Use three of them to suspend the Wreath and the fourth to make a bow at the top. In tying on the ribbons, be sure to work your way through to the frame of the Wreath so the mechanics of encircling and knot-tying do not show. Conceal, in like fashion, the florist wire loop-for-hanging under the bow at the top.

When you are confident the Imperial Star cluster is dry, wire it onto the underside of the Wreath with *four* generous lengths of florist wire caught around the tips of the largest Star. They should reach up through the Wreath and the hardware cloth and be secured with a twist. Finally, put the votive candles in their cups.

In the evening I light the candles with long wooden fireplace matches. I suppose, if you are worried, you could spray the whole business with a fire-retardant, but inasmuch as the flame is confined to the jars, I don't feel it is necessary. However, I'm not one to fall off stepladders either, so suit yourself.

A word about my choice of bittersweet: a *good* Christmas red is so hard to find that I prefer this touch of flame. Colonial Candles make a beautiful bittersweet; the florist has a matching ribbon; and Krylon puts out a spray-paint (Tangerine) which harmonizes perfectly. (You might want to use that on your Star instead of gold.) But in any case, this bittersweet, combined with evergreens, is luscious, lighthearted, and lovely. I carry the theme throughout the house.

KISSING BALL
(Color Plate V)

You'd never think, just to look at it hanging there, so innocent and charming, that it would be at all problematical to make. Just because of the ribs in it! You'll find it all mechanics and no esthetics—until you come to fill it! And then it's such a delight at all seasons, winter or summer, Christmas Eve or June Night, that there seems to be no choice but to make one!

Equipment	Materials
Coarsely serrated snips (if you have them)	Shiny, ribbed can 6 inches across (dehydrated mashed potatoes)
Ball-pein hammer	Deviled ham can 2⅝ inches across
Awl	2 shiny cans with rich gold linings
Long-nosed pliers	for Staghorn Stars and ribbands

Equipment
 Gloves
 Chopping bowl
 1-inch dowel, pipe, or broomstick

Materials
 Krylon Metal Primer Spray Enamel
 Oasis
 Florist wire
 Posey Clay or Vogue Stikum
 Decorette ribbon in gold and silver
 for bow
 Campbell soup can for cutter

You and your family will be eating mashed potatoes for months, but never mind! You need a can that big to get the effect you want. Put

Kissing Ball

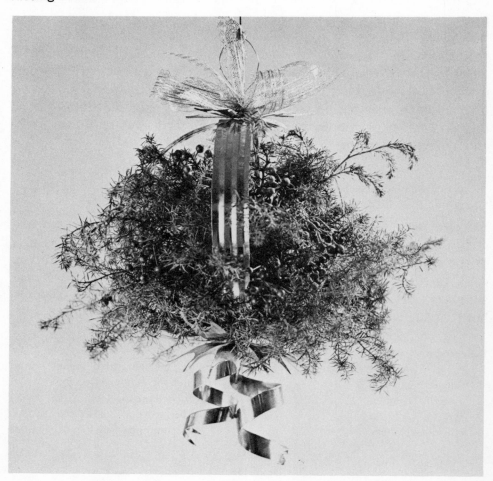

on gloves. Remove the lids, rims and seam. You may want to check Techniques.

V-e-r-y carefully open the can. Do *not* put a crease in those ribs. There are two ribbed sections measuring $7/8$ of an inch which you need. To get them, hold the piece of tin concave side up and remove the plain strip along the outer edge. Then, with utmost care, cut the ribbed strip you want. It will catch on the glove of your cutting hand. Gently free it by wiggling your fingers and twisting your wrist. Try, oh so hard, not to make "hangnails" as you fight your way along. You want an absolutely true, straight edge, and no creases. Determination does it. (Isn't that true of everything?)

To get the other ribbed section, turn the piece of tin around and proceed as before.

Before you try to curve the strips into hoops, *hammer flat both ends* of *each* strip to a depth of 1 inch. This will make wiring them together much easier.

To curve the strips without creasing, g-e-n-t-l-y wrap them around successively smaller cylinders until their ends overlap. Start with a cylinder almost as large around as the original can, like a kitchen mixing bowl or a 3-pound coffee can. Then reduce the size of the cylinder an inch or two and wrap again, etc. until finally the ends overlap easily.

To secure the hoops, punch two holes in one end of each strip. Form a hoop, overlapping the ends $1/4$ inch and, with the awl, scratch through the existing holes to mark the spots for two holes in the other end. With hammer and awl, make those holes and secure the hoop with a 2-inch wire U. Squeeze it flat with the long-nosed pliers.

Repeat with second hoop.

Fit one hoop inside the other. Secure them at right angles to each other with tiny bits of Posey Clay or Vogue Stikum. Then, with hammer and awl (from the inside) make two more holes through both thicknesses of hoops, top and bottom, and secure them together with wire.

Make a loop for hanging while you're at it.

If you have the deviled ham can, fine. If not, cut down another can $2 5/8$ inches wide to 1 inch in height.

Place can in chopping bowl. With ball-pein hammer, beat the bottom of the can until it conforms to the shape of the chopping bowl. You will then see that it fits quite nicely inside the hoops. If you do not want it to show, spray-paint it with Krylon Metal Primer which harmonizes with most live greens.

As for the Oasis, cut a cylinder from the block, using a derimmed Campbell's Soup can as a sort of cooky cutter. (This cylinder will make enough for two Kissing Balls.) The Oasis should extend an inch above the top of the container, I am told. Gives you more accessible working area, and a larger source of water. And it certainly works! A friend of mine took two Kissing Balls on a ninety-day lecture tour, and returned them to me looking just like new!

Now you have the makings of a thoroughly utilitarian container. All that remains is to ornament it if, indeed, you care to. I have found Staghorn Stars with ribbands most satisfactory. They add a little finish and flourish. But perhaps you'd rather use a sprig of mistletoe and bright ribbon. If you do choose to use Staghorn Stars, however, make one 6 inches across and the other 4 inches across, gold side out, following the instructions for the basic Scandinavian Star.

For the ribbands, cut two 8-inch strips, ½-inch wide, from the remnants of the cans you used for the Stars (so they match). Curl them around a broomstick or 1-inch dowel or pipe. Pull them out, corkscrew fashion. Notch one end of each and put a hole in the other.

Now wire everything together—with hammer and awl, put a single hole in the center of each finished Star. Positioning the larger star over the smaller, send a length of wire down through to catch the two ribbands and return. Bring the ends of the wire across the inside of the hoops and twist tight. Flatten with long-nosed pliers.

Put a little wad of Posey Clay on the wire twist and press the beaten container into place. Tie a crisp bow for the top and fill it with evergreens and berries. As you see, I used Chamaecyparis and rose hips. Boxwood is charming and very neat.

SUNFLOWER SCONCE
(Color Plate VIII)

Equipment
 Coarsely serrated snips
 Ball-pein hammer and board

Materials
 2 large, shallow cans with bright gold linings (2 inches deep and 4 inches across)
 1 bright gold lid of same diameter
 Shiny pull chain (cut to fit inside perimeter of can)
 Weldit Cement

Equipment
 Chopping bowl
 Metal pipe or broomstick

Materials
 Candleholder drip cup from the
 dimestore
 1½-inch strip, 12 inches long, from
 V-8 juice can
 Rubber cement and plain paper
 Candle

Remove top rim from each of two cans.

Divide the sides of the cans into approximately 1-inch sections (see Techniques).

Bend the sections out so that they extend horizontally. Hammer them out from the wrong side if necessary.

Fringe (see Techniques) all the sections on both cans, right to the rim, holding the third finger of your helping hand in the way so the fringe can't curl down.

If necessary, hammer the fringe a little bit, but it looks thicker and more sunflowery if it's shaggy.

Place the cans back to back so that the gold-fringed one lies behind the silver-fringed one. Glue the two pieces together with Weldit Cement.

To make the gold center, fringe the extra lid to a depth of 1 inch, leaving a plain center 1½ inches wide. Hammer the fringe flat.

Place the fringed lid in the chopping bowl, gold side down. Beat it until it conforms to the shape of the bowl. (See Techniques, On Beating Tin, if necessary.)

Place the lid, domed side up, in the center of the Sunflower. Push on it with your forefinger until it spreads to within ¼ of an inch from the rim. Remove.

Glue shiny metal chain in place with Weldit Cement.

Apply Weldit to the tips of the fringed lid from the inside. Allow to become tacky, put in place, and let dry.

Meanwhile, make the scroll to support the candle. (See Techniques, On Making Scrolls.) The curve in the scroll will use 6 inches, or half, of the strip. The remaining straight half will extend up behind the Sconce. Cut that end in a curve to fit the rim and glue in place *against that part of the fringe where the seam comes*. (This both reinforces the strip and also helps to obscure the seam by placing it directly behind the candle.)

Make a little V-shaped hook for hanging with two strands of fringe bent together.

Hang the Sconce on its nail on the wall. Score the base of the candle-holder and the spot on the top of the scroll-curve where you want it to go. Glue with Weldit. Let set overnight before firming candle in place. I use a 4¾-inch candle in this Sconce. (If, for some reason, your ten-cent-store does not happen to have the candleholder in stock, you can make one from the end of a can. See Angel Sconce.)

ANGEL SCONCE
(Color Plate III)

Equipment
 Finely serrated snips
 Ball-pein hammer
 Chopping bowl
 Metal pipe or broomstick
 Vise (if you have one)

Materials
 Praying Angel
 2½-inch bright gold lid for halo
 2¾-inch can end (rim and lid intact) for drip cup
 1½-inch tin strip, 12 inches long for scroll
 Dowel to raise angel from backing
 Krylon Flat White Spray Enamel
 Krylon Metal Primer Spray Enamel
 Weldit Cement
 Candle

Make Praying Angel from sardine can lid, according to directions previously given. Cut her skirt to conform to shape of can. Spray-paint her flat white. Give her a halo made from a Sparkler star (see Trifles for the Tree) using only eighteen of the thirty-two sections, cutting out those behind her neck. Glue on.

To make reflector, remove rim from the bottom of the sardine can, if you wish, and divide sides into 1-inch sections (see Techniques). (You *can* cut right through the tin and leave it on for trim, but as you see, I removed it and curved each section just a little.)

Form a scroll (see Techniques, On Making Scrolls) to hold the drip cup.

To make drip cup, remove entire end (rim and lid combined) from can 2¾ inches in diameter (putting can into opener horizontally just as you would if you were removing the rim separately).

Place can end in bottom of chopping bowl and beat it with ball-pein hammer until it is nicely curved and conforms to the bowl.

Spray-paint the inside of the drip cup flat white like the Angel.

When dry, turn it over and spray-paint all three pieces of the sconce backing (drip cup, scroll, and reflector) with Krylon Metal Primer.

(May I draw your attention to the fact that Krylon Metal Primer is a beautiful shade of olive-green. It harmonizes perfectly with most greens in nature and goes beautifully with antiques. I use it almost exclusively.)

Assemble the Sconce. First glue the dowel (cut from an old broomstick) to the back of the angel. She should be raised about ½ inch from the reflector so her wings can be bent back in a natural position and cast a little shadow. Then glue the dowel to the reflector.

Glue scroll to back of reflector (judging the distance that it should extend below by holding the drip cup in the position it will eventually take). Let dry.

Make hook from which to hang the Sconce out of a scrap of metal, and glue to back. Let dry.

Hang Sconce in place on wall. Then glue drip cup in place. Let dry overnight before placing candle in position. I use a white votive candle in this Sconce, but I'm frank to say I don't light it for fear of spoiling the Angel's pristine white robe. She lends quite enough atmosphere without the flame!

SPARKLER MOBILE

Viewed in color, this is pure enchantment, and so right for a little girl's coral-colored bedroom.

Equipment
 Coarsely serrated snips
 Awl
 Hammer

Materials
 3-pound coffee can rim
 9 Campbell Soup can lids with soft gold linings
 18 sew-on rhinestones
 18-inch length of lacy Decorette ribbon labeled *Better Times on red* (actually shocking-pink on orange)
 5 feet of Tie Tie gold tinsel cord
 Gold thread (sewing machine weight)
 Hair wire
 Dri-Mark felt markers (oil based) in shocking-pink and orange
 Weldit Cement
 Krylon Gold Spray Enamel—optional

Start with the Frame

Remove rim from 3-pound coffee can (see Techniques). If it is any obtrusive color like dark blue, spray-paint it gold.

Cut three 9-inch strands of gold cord and tie them on the rim at three equal intervals. Trim the knots and secure them with a drop of glue.

Pick up the strands by their tips and bind them together with fine wire about $1\frac{1}{2}$ inches down from the top. Make a loop for hanging.

Cut two 12-inch lengths of gold cord for bows to be placed front and back of the "neck" (Fig. 1) and catch in place with a 6-inch length of gold cord.

Hang frame from a handy hook in readiness for the strings of stars. A kitchen towel rack is good.

Make the Stars

Mark the center of each lid with a large Dri-Mark dot $\frac{3}{8}$ of an inch wide. Cutting to that dot, divide each lid into sixteen sections (See Sparkler star diagram). Clip one section to a point for hanging; snip notches in remaining sections.

Color the sections on the silver side, alternating pink and orange.

Glue "diamonds" in the center of both sides with a drop of Weldit.

With awl and hammer, make hole for hanging in pointed end.

Push pink sections back and orange sections forward to give dimension to the stars.

Assemble the Mobile

Cut three 9-inch and three 13-inch lengths of fine gold thread.

Tie a star on one end of each of the 9-inch strands and tie the other end to the rim in the *middle* of each of the three intervals, so that the diamond in the center of the star hangs at a point 8 inches below the rim.

Tie a star on one end of each of the 13-inch strands. Slip a second star onto the thread and secure it with a loop (Fig. 2) 6 inches higher up.

Now tie the *long* strands to the rim at the points where the gold cords are attached. The stars, whether on one strand or another, should hang at points 4 inches, 8 inches, and 12 inches below the rim.

Make any necessary adjustment; knot ends firmly and trim.

Apply a fine line of glue to rim (a little extra on the knots) and gently, but firmly, press the lacy ribbon into place.

I like the richness of gold lids and gold cord with hot pink and orange, but if you can't bring yourself to eat Campbell's Soup and find that your soup comes in cans with silver lids, then for unity's sake use silver cord and silver thread and silver spray-paint.

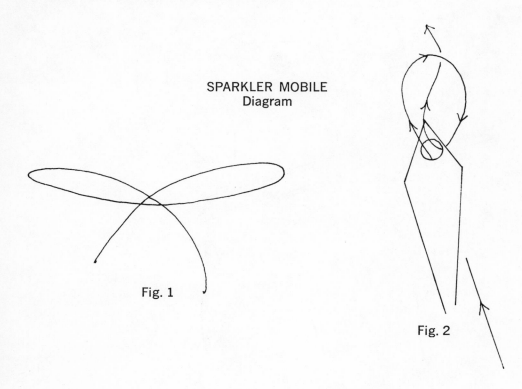

SPARKLER MOBILE
Diagram

Fig. 1

Fig. 2

BIRD MOBILE
(Color Plate XIII)

Mobiles are magical, mesmerizing, and (excuse me), "murder" to make. They are absorbing, fascinating, exasperating, and utterly irresistible. I expect to be attempting them the rest of my life. To make this one practically painless, I have given you measurements so that you can assemble the whole Mobile on a table without experimenting. You will have to make adjustments, of course, finding the exact centers of balance in each cross-arm. (They can vary by as little as $\frac{1}{16}$ of an inch!) But other than that, you should have no difficulty, and your Mobile will float so freely and effortlessly you will marvel.

BIRD MOBILE ANGEL KITTEN
Pattern

Equipment
 Long-nosed pliers with wire-cutter

Materials
 Architect's linen, pencil, and scissors
 8 Bright Birds
 1 Bird Mobile Angel Kitten
 3 36-inch wire florist stakes (or 1
 36-inch stake and coat hangers)
 Krylon Brass Spray Enamel
 Gold metallic yarn
 Weldit Cement
 Fishing swivel and hook (optional)

Make eight little birds (see Bright Birds under Trifles for the Tree) with small hair-wire loops for hanging.

Trace enlarged Bird Mobile Angel Kitten (Fig. 1) onto architect's linen. Cut out. Follow directions for Angel Kittens, (see Trifles for the Tree). (You dont *need* to include the Kitten. Omitting him would simply move the balance point in the topmost cross-arm farther along toward the other section of the Mobile.)

Cut the florist staking into these lengths:

1 5½-inch piece	1 9¾-inch piece
1 7-inch piece	1 19¾-inch piece
3 7¾-inch pieces	

With long-nosed pliers, make loops in ends. Spray-paint with Krylon Brass Spray Enamel so wire will be all alike and harmonize with the Birds.

Assemble the Mobile with gold metallic yarn, according to measurements given, starting with the lowest cross-arm in one section or the other. (I use gold metallic yarn purposely, because it shines prettily and brassily, has good visual weight with the staking, is perfectly pliable —which gold tinsel cord is not—and adheres to the wire arms well enough to keep the whole thing from collapsing while you make adjustments—almost! Cut generous lengths of yarn so it will be easier for you to tie.)

You will notice that I have not recommended loops at the balance points in the cross-arms. It is not easy to form a loop at a precise point, or to correct it if it is "off." So I suggest that you *pull* the yarn tight enough (do *not* knot it) to hold while you move it to the right or left with your fingernails until you find the exact spot. Then knot, clip, and glue it permanently in place. Suspend the Mobile from a swivel and hook.

BIRD MOBILE
Specifications

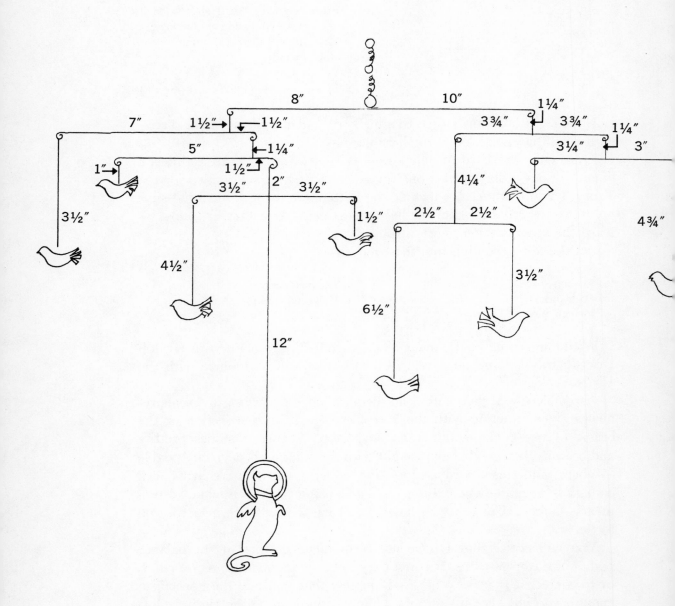

PART FOUR

TRINKETS FOR GIFTS

POMANDERS, EARRINGS, AND PINS

Actually, all the Trifles and Treasures in this book would make pleasantly surprising presents for your friends at Christmas, but these Trinkets fall into the category of typical gifts. Bangles and bells are of course basic to Christmas. Pins in the shape of wreaths or bows are always appropriate. And scented pomanders are ideal for those friends who "have everything," but who appreciate a tangible token of your affection.

You will find that one idea suggests another, and that you will adapt these designs to your friends' tastes. But you already know that it matters not so much what you give as that you made the gift yourself, and that it comes from your hand and your heart.

HEART POMANDER

For years I have been making pomander balls for gifts by sticking cloves in oranges, shaking them in a bag of cinnamon and orris root, and tying them up with extravagant ribbon for my friends to hang in their closets. But I never knew until recently that the French "amber apple" was not a real fruit, but a perforated, metal ball with aromatic substances in it, worn on one's person as a guard against infection. How very pleasant it must have been for everyone concerned always to be giving off that sweet fragrance. Gives me an idea for a locket just

161

the size of an André Richard scented wafer—or a belt with little hollow hearts dangling from it.

Equipment
Finely serrated snips
Ball-pein hammer
Awl
Dapping block or chopping bowl
Board for hammering on
Spring clamp

Materials
Lids 3 to 3½ inches across with warm-gold linings
Architect's linen, pencil, and scissors
Rubber cement
Scented wafers, pellets, or potpourri
Gold and silver Decorette ribbon
Gold cord
Weldit Cement

To make this particular Pomander you will need to cut two Hearts, one ¼ of an inch larger than the other. Trace the patterns given onto the dull side of folded squares of architect's linen. Cut them out and center them on lids already coated with rubber cement. See Technique.

Once cut, center the smaller tin Heart over the larger. Holding them firmly together, fringe the edge of the larger Heart by cutting in to the edge of the smaller.

Now perforate the smaller Heart by placing it, gold side up, on your hammering board and striking a heart-shaped sequence of holes ¼-inch apart in its surface with hammer and awl. If you want more holes, place a perforated shaker cap from one of the herb and spice jars in your kitchen in the center of the heart and hammer through it. Or borrow an even more elaborate design from the Pennsylvania Dutch.

Beat the Hearts, either in the shallow bowl of a dapping block if you have one, or in your kitchen chopping bowl. When beating, always start at the outer edge and work toward the center. In this case, place the point of the smaller Heart, silver side up, in the bottom of the bowl. With short, quick strokes hammer back and forth across the piece until you reach the center. Go all around the edge the same way, always working slowly toward the center, and making the hammer marks so close together that, in the end, the whole surface has a supple, stippled look about it.

Repeat this process on the larger Heart, gold side up, without beating the fringe itself. The fringe, however, *will* curve to fit the chopping bowl as you beat the Heart, and you will have to hammer it flat again, either on the edge of the chopping bowl or on your hammering board.

In order to glue the two Hearts together, they must meet flush, and

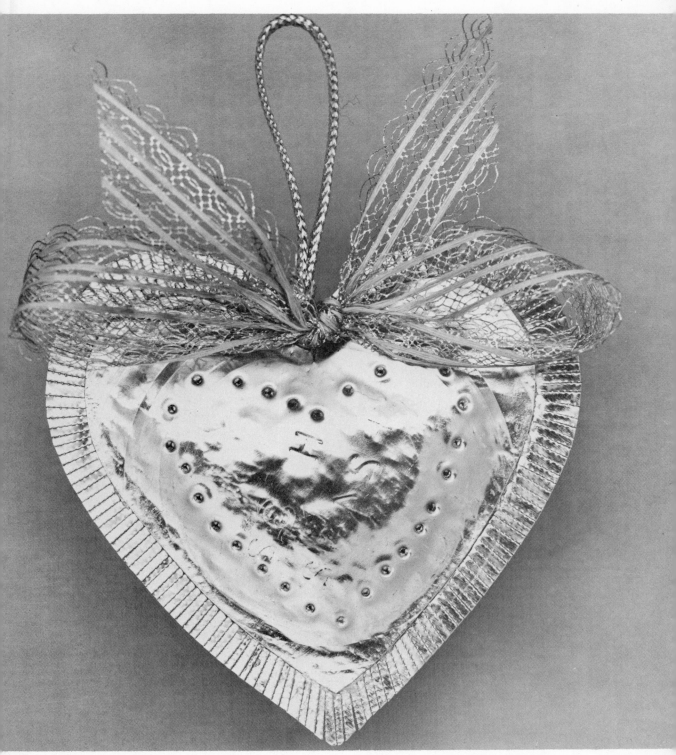

Heart Pomander

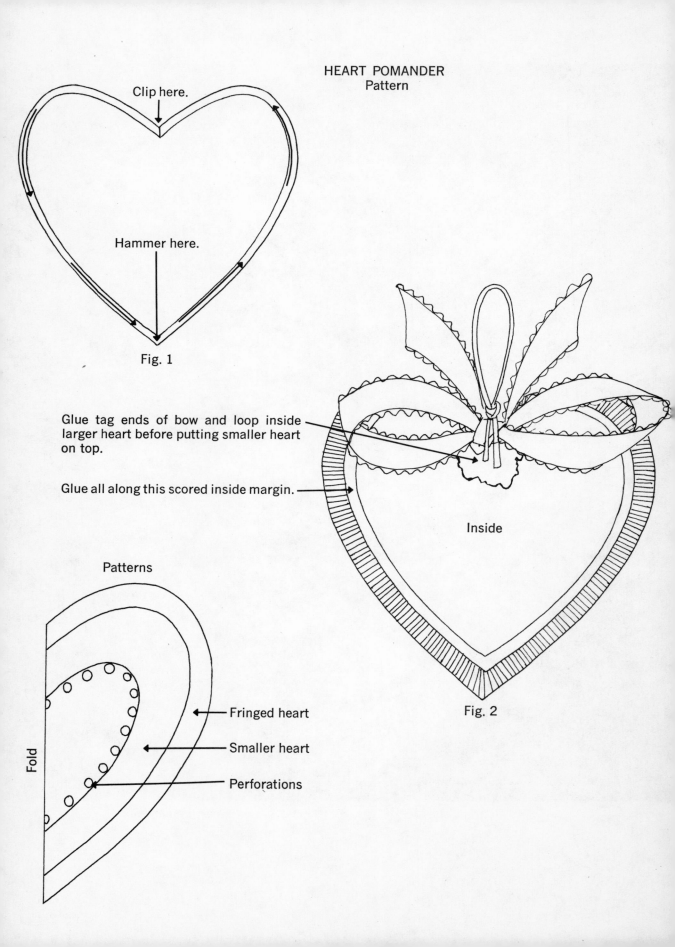

HEART POMANDER
Pattern

Clip here.

Hammer here.

Fig. 1

Glue tag ends of bow and loop inside
larger heart before putting smaller heart
on top.

Glue all along this scored inside margin.

Inside

Patterns

Fold

Fringed heart

Smaller heart

Perforations

Fig. 2

you will have to hammer a border on each $\frac{1}{8}$ of an inch wide. On the fringed Heart this is easy because, as you hammer the fringe flat, you can, at the same time, hammer a $\frac{1}{8}$-inch border *inside* the fringe.

On the smaller Heart the process is a little more difficult. Start by hammering it from the inside. Lay its tip on the flat edge of the chopping bowl and tap it with the hammer. Continue tapping around the edge of the Heart, encouraging it to bend back. Then turn the Heart over (and the chopping bowl, too) and placing the Heart right side up firmly upon it, tap it from the top around the edge until you have succeeded in getting a neat, narrow, $\frac{1}{8}$-inch margin everywhere except at the "throat." There you will have to clip it (Fig. 1) to give a little flexibility to the "shoulders." But don't worry about getting the throat *completely* flat because you will need a little hole there anyway for the bow and loop ends to pass through.

When you've gotten the overall conformation right, *score the metal* where the Hearts touch. This will make for better adherence when you glue it (Fig. 2).

Now make your pretty lacy bow and the loop of cord for hanging. Apply a generous glob of glue to the inside of the throat on the larger Heart. As it becomes tacky press the tag ends of the loop into it; then the tag ends of the bow on top of that. Add more glue if necessary. Position them so that their knots will be on the *outside* of the ornament when the upper Heart is put in place. Let dry.

Fill the hollow Heart with scented pellets or potpourri. Very carefully apply the glue to the scored portions of both hearts. Let them get tacky; then press them together. If you have gotten the conformation right, they will fit perfectly and stick together. Help them along by holding them for a few minutes. Then gently position a spring clamp in the center and let the Heart harden overnight.

BOOKMARKS

(Color Plate X)

Life affords all manner of simple pleasures, not the least of which is the slipping of a slim bookmark between cool pages neatly bound. And it is a continuous pleasure, as you go about your duties, to see the ornamental tip protruding from the volume on the table while it waits upon your leisure. One of the favorites of my childhood was really not a proper bookmark at all, but an oriental hairpin with two long prongs graced by a butterfly with pendulant feelers. Possessing an aura all

its own, it made a completely elegant and extravagant marker and it had a tasselly quality about it that enchanted me. There's something about a tassel, however it is contrived, that is especially appealing, so I've made one for you. Select your tin can carefully for its soft, rich gold lining. Then your tassel will resemble an ancient Etruscan treasure.

TASSEL BOOKMARK

Equipment
 Finely serrated snips
 Hammer

Materials
 Sides of cans with soft, rich gold linings (Tiny whole onions or cream-style corn often come in these.)
 Architect's linen, pencil and scissors
 Rubber cement

Trace the design from the book onto the dull side of a piece of architect's linen and cut it out. Brush a suitable portion of the flattened can with rubber cement and apply the pattern (Fig. 1). Cut out the tassel with your finest, serrated snips.

Remove the pattern, rub off the excess cement, and improve the silhouette of the knot and tassel.

Fringe each end of the Bookmark by making cuts 1/16-inch wide and 3/4-inch deep as indicated. Trim down the sides of the Bookmark (so that it will be in proper proportion to the tassel end) by cutting off a 1/16-inch strip on each side, also as indicated in the pattern.

Hammer the Bookmark on both sides until perfectly flat, being careful not to mar the soft gold. (You might protect it with an old hankie.)

Spread the fringe a little, so it looks free and natural. Hammer it once more to fix the fringe in place, and you're done!

You can make a dozen of these in next to no time, and if you have decided to simplify Christmas by giving books to everyone, they make a charming extra touch caught into the bow of your gift wrapping.

To me, the gold-tasseled Bookmark is beautiful just as is, but if you don't like it quite so plain, place the pattern on the part of the can that is ridged. Hammer it very gently, if at all. You can probably smooth the tin with your fingers and will only have to hammer the fringe.

Then, too, you could *paint* the Bookmark, borrowing striped designs from military orders or running a garland of simple leaves and flower forms along its length. But since it is quite right as it is, why not make another Bookmark which really *needs* to be painted . . . like a rose. Everyone loves a rose and it is perfect for a small volume of poetry.

BOOKMARK
Patterns

|← ⅞ inch →|

Pink rose with light green tinge on all lines

Light green sepals

Light green leaves

Dark green veins

Dark green main stem

Rose

|← ¾ inch →|

Cut off one strand fringe on each side.

Tassel

|← 1 ¼ inches →|

Bud: all outside lines dark light green within

Pink center

Light green highlight in dark green ovary

Light green leaves

Dark green veins

Dark green undercurls

Dark green main stem

Rosebud

Here are two versions to choose from, one full-blown and one in bud.

I have intentionally made one simpler than the other. Perhaps it would be best to start with the full-blown rose, but whichever you choose, the procedure is much the same.

Equipment
 Finely serrated snips
 Long-nosed pliers
 Hammer

Materials
 1⅛ inch strips from heavy V-8 juice cans (partly for their rich gold linings)
 Architect's linen and pencil
 Carbon paper and ball-point pen
 Krylon Crystal Clear Lacquer
 Talens Glass Paints
 Fine sable brush
 2 bottle caps
 Turpentine

Trace design from the book onto the dull side of a piece of architect's linen and from there, with carbon paper and ball-point pen to a strip of tin sprayed with Krylon Crystal Clear Lacquer.

Most of you being right-handed will find it expedient to cut out the design *counterclockwise*. Bypass the corners that come toward you and return to them later. The arrows may assist you. If you are making the rosebud, save the little teeth in the leaves until you have cut the whole thing out. Then go back and cut them tiny, tiny; you *cannot* cut them too tiny.

If in cutting, you have bent the metal, straighten it with the *long*-nosed pliers and hammer the Bookmark flat. Improve the silhouette where necessary. Hammer again.

Remove carbon paper marks with turpentine or other solvent.

Now you are ready to paint. I have tried to indicate lines and shading. You might draw little guidelines with an ordinary pencil or scratch them with the awl. I do not suggest grease pencil or carbon paper since they would both show through the paint. Most of you who love roses enough to want to make them, have some idea of their construction, anyway. Perhaps you even have pictures of them in your library. Studying those pictures may help you interpret my drawing. If you are only going to paint one side, paint the silver.

You may wonder why I do not recommend painting the roses with Dri-Mark pens since they are so satisfactory in so many instances. The reason is that you handle a bookmark frequently, and none of those nylon pens have either the depth or durability of the lustrous glass paints. Start with the Talens dark green just as it comes from the can.

Contrary to the instructions, I flow it on quite thick because I want the richness of hue. Do all dark-green areas at once. Let them dry a little while you mix the light green.

Into a bottle cap, drip two drops of dark-green paint from your brush. Wipe the brush and drip in four drops of yellow. See if that doesn't make a good leaf green. Adjust if necessary. Paint all parts calling for light green. Let dry while you mix the pink.

If you are making the rosebud, drip one drop of red into the second bottle cap. Add two drops of white and one drop of yellow. See if that doesn't make a warm, pale pink. Adjust to your own taste. You will have to increase the proportions if you are making the full-blown rose because that calls for more paint.

By now it should be safe to put the pink in place. Once that is done, go back to the dark green and sketch in the veins with brush and paint. I think they should blend a little, but that is a matter of personal taste. When you finish veining, you may want to accent the dark green areas of the stem with another drop or two of paint, just to give a little more sense of dimension to something that is, after all, perfectly flat.

Wipe the brush; dip it in the light-green paint and, very lightly, make shadows at the base of the petals on the full-blown rose, or draw those little hairlines into the pink part of the bud.

I love *all* bookmarks, but that rosebud is one of my very favorites. And, incidentally, a little snipping away at the full-blown rose and you'd have a chrysanthemum! But that's for the next book.

IMPERIAL EARRINGS

These Imperial Earrings I dreamed up in gratitude to a dear friend who saved all her beautiful dog food cans for me. Let me warn you, however, that if you ever make yourself a pair, you will be besieged by requests to make them for your friends. Splashy earrings are very much in vogue, even among young college men who wear just one! These I have left bright gold, but they'd be marvelous spray-painted in brilliant colors to match your dresses.

Equipment
 Serrated snips
 Awl or compass
 Round-nosed pliers

Materials
 Shiny gold lids 2¾ inches across
 Earring findings with rings for sus-
 pending ornaments
 4 small links
 Decora upholsterer's tacks
 Weldit Cement
 Grease pencil

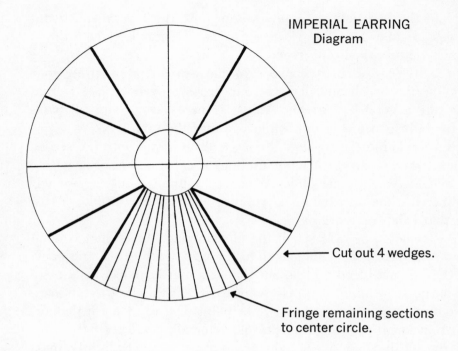

IMPERIAL EARRING
Diagram

← —— Cut out 4 wedges.

Fringe remaining sections
to center circle.

With grease pencil, divide lid into four equal sections.

Place a dime in the center of lid and mark around it with awl or compass stem.

With grease pencil, draw cutting lines for wedges as shown.

Cut out wedges.

Fringe each section down *to* that circle. Be *exact* about this because that circular shiny circle is an integral part of the design. Notice that the fringe is wider at the outside of the can lid than it is as it reaches the circle. Let the fringe curl *under* as you cut. Then follow Steps 2, 3, and 4 of the Imperial Star design, illustrated in procedural photographs. (If you haven't already made an Imperial Star, it would be well to do so, just to familiarize yourself with the process before attempting these Earrings whose sections overlap.)

When you have finished curling all the sections, arbitrarily select one strand from the middle of any section as the one from which the ornament is to be suspended. Make a loop for hanging at the tip.

Cut the shaft from the upholsterer's tack and glue it in place. Assemble the earring as shown in the photograph. You will notice that I

use two links, instead of one, so that the ornament hangs parallel to the neck rather than at right angles to it. Suit yourself on that.

INDIAN BELL EARRINGS

It would seem that all little girls, these days, want to have their ears pierced. Once accomplished, they then collect earrings by the basketful. As if she didn't already have more than she could accommodate, my daughter begged me to make her some tin ones. And I must admit that even though I was brought up to think children should almost never wear jewelry, these little bells look quite appropriate to her quaint Victorian face. And they make the sweetest tinkle!

Equipment
 Finely serrated snips
 Round-nosed pliers
 Long-nosed pliers
 Hammer
 Awl

Materials
 2½-inch lids with *soft* gold linings
 (Campbell's Soup ideal)
 8 tiny links
 Earring findings (either pierced or
 "pretend")
 2 gold beads
 Grease pencil and ruler
 Weldit Cement

Divide each lid into eight equal sections, using a grease pencil and ruler. Cut pieces.

With awl, scratch design provided in diagram on each section. Cut out. (Each bell-wedge should measure one inch in length.)

With hammer and awl, make holes in each little circle *from the gold side*. Turn over and strike once more from silver side. Hammer flat. (Don't bruise the gold!)

With round-nosed pliers and long-nosed pliers, shape the wedges into cones following the instructions given in the Penobscot Indian Wind Chime for Figs. 3, 4 (omit 5 since these bells are so small), 6, 7, 8, and 9. (You may want to practice on a larger wedge first to get the feel.)

Assemble the Earrings as shown in the photograph above, noting that the middle bell in each uses an extra link to allow it to hang lower.

Put tiny drop of Weldit Cement on earring finding where gold bead is to go and push bead into place. Aren't they charming? Would you like to make the Bracelet?

Indian Bell Earrings

INDIAN BELL BRACELET

I happened to have the basic bracelet shown here and I simply added links and bells. But I have since made a similar bracelet of a craft wire called Nu-Gold (see Jewelry Finding Sources) which is softer, a little heavier gauge, and, therefore, not quite so satisfactory in some ways, but very charming and early Mediterranean in character. You may prefer to use an old costume jewelry bracelet of your own, but if you don't have one, here are instructions for one like mine.

Equipment
 Round-nosed pliers

Materials
 Nu-Gold wire
 7 little bells
 7 tiny links
 Measuring tape

Cut an 11-inch length of Nu-Gold wire.

Holding the tip of one end with the round-nosed pliers, coil it around the pliers in a complete 360-degree turn as shown in Fig. 1.

For the loops, measure off a point 2¼ inches along the wire. Grasp the wire at that point with the tip of the round-nosed pliers and twist it up, over toward you, down under, and on (Fig. 2).

For the next loop, measure a point ⅝ of an inch beyond the last. Again grasp the wire with the tip of the pliers, twist it up, over, down and on as before.

Make seven loops in this fashion. Each loop will use up at least ⅛ inch, so that would make them come at ½-inch intervals.

Coil the unfinished end like the other and twist the coils at right angles to the bracelet so they hook (Fig 3). That's the way they did it for centuries!

Make seven little bells following instructions for bells in Indian Bell Earrings and attach them with seven little links.

My adorable twelve-year-old daughter makes these as slave bracelets for her schoolmates. Can't you just visualize that tribe of little Indians?

INDIAN BELL EARRINGS
Diagram

INDIAN BELL BRACELET
Pattern

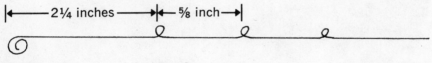

|← 2¼ inches →|← ⅝ inch →|

Fig. 1 Fig. 2

Indian Bell Earring and Bracelet Pattern

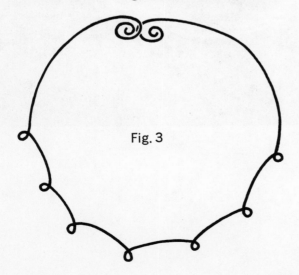

Fig. 3

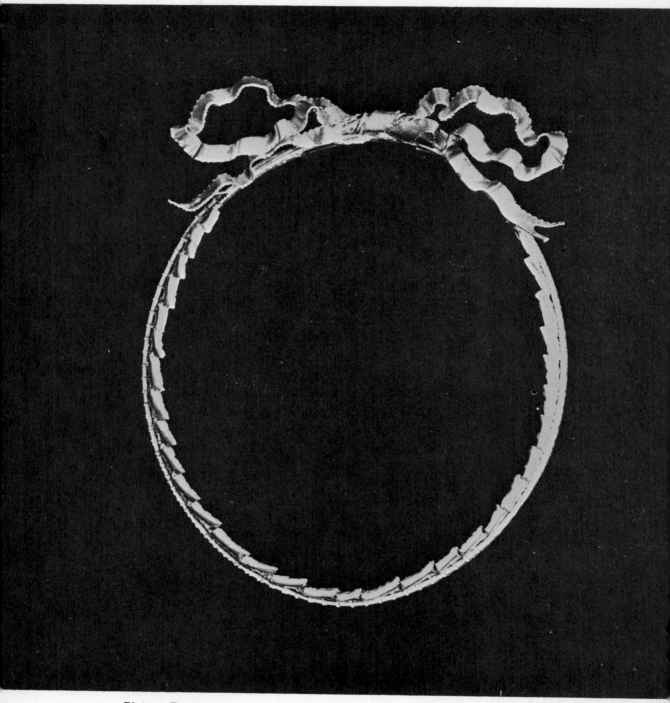

Picture Frame

PICTURE FRAME

Do you, too, face the annual dilemma of what to do with all those awful snapshots the children have taken in school? They come home so proudly with them, one simply has to be gracious about it. This is one way of ameliorating the situation. Once you get the knack of crimping the bow, it couldn't be simpler, and it doesn't look quite so bad as the original cardboard frame! Come Christmas we shoot them out to all the cousins and camping comrades, and everyone is quite pleased.

Equipment
 Finely serrated snips
 Round-nosed pliers
 Gloves

Materials
 Rim of suitable size for snapshot
 ⅛-inch strip of tin at least 12 inches
 long
 Weldit Cement
 Krylon Bright Gold Spray Enamel

To make the basic frame ornament the rim by making vertical cuts in the ragged edge to the rim proper (see Techniques. On Ornamenting Rims, if necessary). Squeeze rim with palms of both hands til proper oval shape.

To make bow, fold the ⅛-inch strip in half to find the center. Then open it out again and refold as shown in diagram. (Good idea to wear gloves for this whole procedure.) Be sure the bow ends extend well beyond the bow proper.

BOW STRIP Pattern

Pinch strip between fingers here and with round-nosed pliers twist over and over twice to simulate knot.

Squeeze the folded strip together at the center point with the thumb and forefinger of your helping hand, and with the round-nosed pliers, twist the folded strip over *twice,* until it appears to be knotted in the middle. Straighten the flat bow somewhat, pulling the bow ends down and twisting the loops into some sort of bow position.

Then with the round-nosed pliers, crimp the loops with twists of the wrist until it resembles the bow in the photograph. You want the bow to face you, so you will have to "persuade" it. (The process is difficult to describe, but it's really not difficult to do. It's just awkward.)

Crimp the bow ends in the same way. Notch their tips.

Pinch the bow so that it conforms properly to the frame and glue it in place with Weldit Cement. Let dry overnight. If the conformation doesn't quite please you, it will be dry enough in the morning to hold firm while you bend it to a position you prefer.

I don't bother to have glass cut for these frames, and I must confess I use the backing that comes with the photograph to support the frame on the table, but it's not very satisfactory and hereafter I shall make tin backings instead. Of course, you could avoid that problem altogether by equipping it with a gold tinsel cord loop for hanging on the wall instead.

You may or may not need to spray-paint the frame, depending upon the metal in the rim and strips, but Krylon Bright Gold would be best if you find you do.

BOW PIN

The bow in this pin is made exactly like the one on the picture frame except that it's fashioned from a ³⁄₁₆-inch wide strip, 15 inches long.

As you can see, I suspended two little earring bells from a 2-inch length of gold tinsel cord. But I would recommend that you make the regular Penobscot Indian Wind Chime bells instead (from a Campbell's Soup lid), tucking the knotted end of the tinsel cord inside the cones before you squeeze them tight. Then they will fall perfectly straight and tinkle delicately as they touch.

Glue the pin-finding on the back of the bow with Weldit Cement and the loop of tinsel cord in the middle of it.

This little bow pin is really quite charming on one's lapel, the side of one's hat, or even on one's daughter's pony tail.

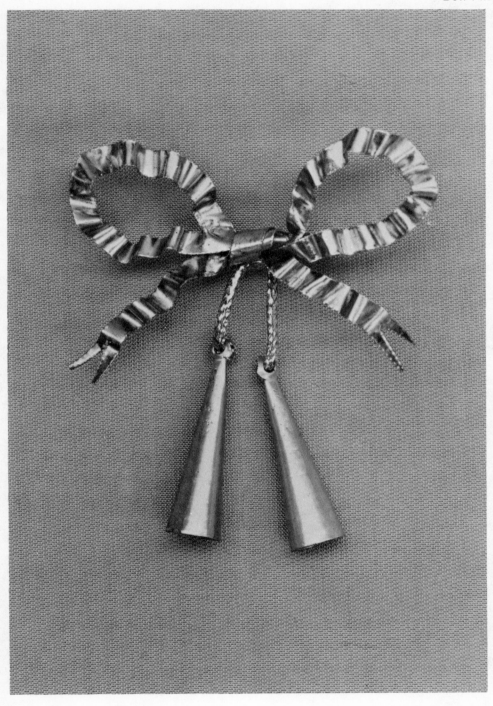

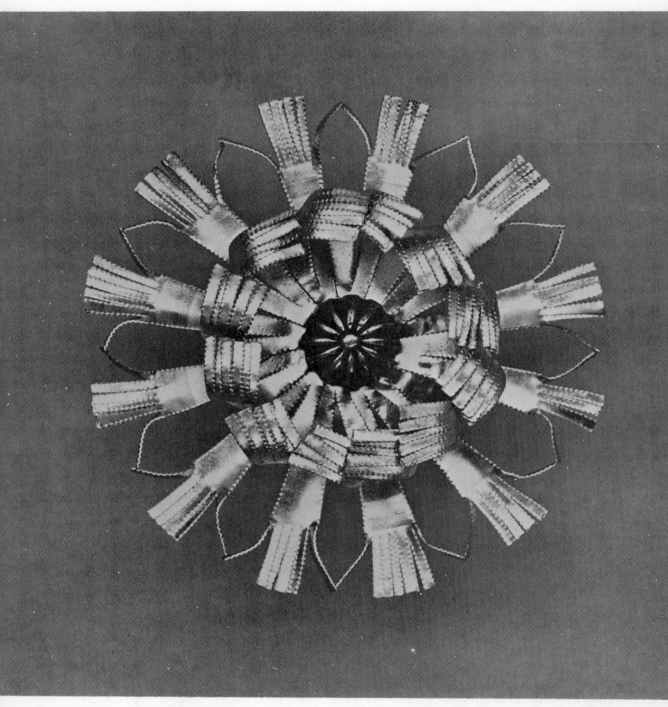

Fringed Whorl Pin

FRINGED WHORL PIN

This is the little pin I referred to earlier in the book under Stars, in describing the uses of the Fringed Whorl motif. As you can see, you need only select a 2½-inch lid of softest gold (Campbell's Soup would be ideal); make a Fringed Whorl according to the instructions; and glue a pin-finding on the back.

And an enchanting variation of that could be contrived by spraying the back of the lid green, the front white, and the Decora tack, scarlet. Then—can you visualize it?—you would have a green wreath against a snowy ground with a bright berry center!

SOURCES OF SUPPLIES

Most of the supplies recommended in this book are obtainable either at, or through, your local hardware store, large chain store, plumbing supply house, stationer's, art supply store, or hobby shop.

On the other hand you may prefer to order one of these kits:

BASIC TINCRAFT KIT—$17.00 plus postage*

Finely serrated aviation snips
Coarsely serrated aviation snips
Round-nosed pliers
Long-nosed pliers

GENERAL TINCRAFT KIT—$27.00 plus postage

Finely serrated aviation snips
Coarsely serrated aviation snips
Round-nosed pliers
Long-nosed pliers
Ball-pein hammer
Awl
Board

Chopping bowl
Weldit Cement
Decora upholsterer's tacks
Hair wire
Florist wire
Posey Clay

Both obtainable from: Welch's Hardware, 21 Main Street, Westport, Connecticut, 06880. (Will aslo supply single items.)

* Prices approximate and subject to change.

FRAGRANCES

Potpourri—Mrs. Adelma Simmons, Caprilands, Coventry, Connecticut
Scented Pellets—Marly, Inc., 350 Fifth Ave., New York, New York
Scented Wafers—André Richard, Co., 100 West 22nd St., New York, New York

DAPPING BLOCK AND JEWELRY FINDINGS

Allcraft Tool & Supply Co., (including Nu-Gold wire)
20 West 48th Street
New York, New York 10036

SHEET TIN

Telephone Directory Yellow Pages: Plumbing suppliers; Sheet metal companies

ART SUPPLIES

Architect's linen
Talens Vercolor (transparent glass paints)
No. 1 Sable brush-round

Obtainable from: Fine Art Stationery Co., 68 East State Street,
Wesport, Connecticut, 06880

INDEX

Heavy type indicates a drawing or a black-and-white photograph.
Plate references are for illustrations in color.

ABOUT THE AUTHOR

Lucy Sargent grew up in Cambridge, Massachusetts, in the Beacon Hill Christmas tradition of caroling and candles. The season is inexpressively dear to her and the decoration of her home a happy occupation. An art major at Wellesley College and a secretary at the Metropolitan Museum of Art, she has long been concerned with the arts. While bringing up four children, she has used her artistic talents—and extraordinary energy—to create beauty in her home and in her town. Music, gardening, and interior decoration are her principal enthusiasms. Her insoluble problem: how to accomplish all she has in mind in one lifetime. Friends claim she is doing it!